IMAGES OF AMERICA

THE STROUDSBURGS
IN THE POCONOS

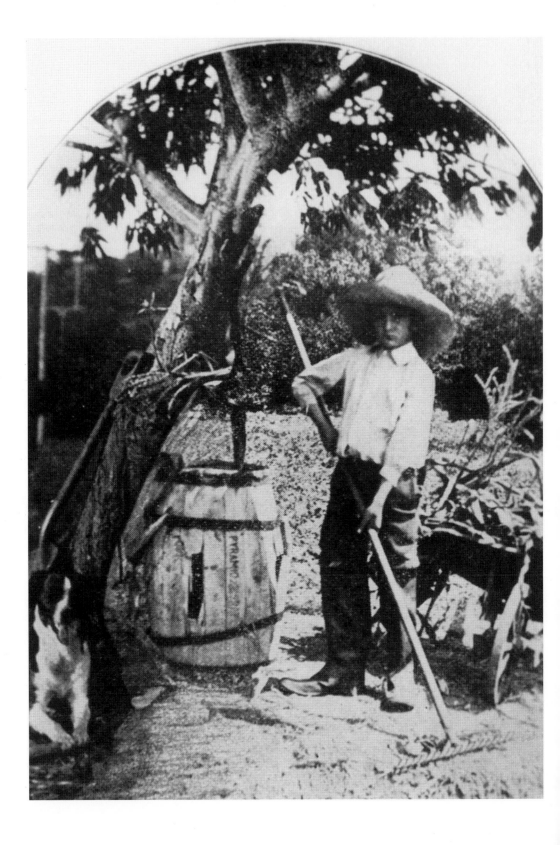

IMAGES OF AMERICA

THE STROUDSBURGS
IN THE POCONOS

MARIE AND FRANK SUMMA

ARCADIA

Frontispiece: A young lad of the Stroudsburgs did his chores as his faithful companion sat patiently by. In 1915 Hughes Press published a booklet with the picture, entitled "The Happy Life," as a tribute to the boy's ambition.

Copyright © 1998 by Marie and Frank Summa
ISBN 0-7385-1291-5

First published 1998
Re-issued 2003

Published by Arcadia Publishing
an imprint of Tempus Publishing Inc.
Charleston SC, Chicago, Portsmouth NH,
San Francisco

Printed in Great Britain

Library of Congress Catalog Card Number: 2003107163

For all general information contact Arcadia Publishing at:
Telephone 843-853-2070
Fax 843-853-0044
E-mail sales@arcadiapublishing.com
For customer service and orders:
Toll-Free 1-888-313-2665

Visit us on the internet at http://www.arcadiapublishing.com

Contents

Introduction

When the first white settlers ventured into the wilderness now known as "The Stroudsburgs," they entered a vast area known as the Minisink, a land inhabited by the Wolf clan of the Lenni-Lenape Native Americans. The Minisink encompasses a large geographical region stretching 40 miles from Delaware Water Gap to Port Jervis, New York. Within its breadth lie the mountains, plateaus, streams, and river valleys of both Pennsylvania and New Jersey.

On March 27, 1735, Daniel Brodhead, a Marbletown, New York trader, petitioned for land in what is presently East Stroudsburg and acquired permission to settle the land. Scarcely two years later, he brought his wife, Hester Wyngart Brodhead, and infant son down the old copper mine road and settled on what is now East Brown Street in East Stroudsburg. There they raised their family of six sons and a daughter. A later grant of 150 acres extended Brodhead's holdings to what is now Seventh Street in Stroudsburg. Place names soon took on his name, with the settlement becoming known as Dansbury and the Analomink Creek being called Brodhead's Creek.

Brodhead was born April 23, 1693 in Ulster County, New York. He was the namesake of his grandfather, a captain of grenadiers in the realm of King Charles II, who had settled in Ulster County after a campaign that captured New York City from the Dutch. Young Daniel operated as a merchant in Albany. In 1730, he became a licensed Indian trader.

His petition for land evidently created a stir with Nicholas Depui and the Lenni-Lenape Indians. DePui had acquired a deed from the Lenapes in 1727 for 3,000 acres of land in what is today's Shawnee, but had to officially repurchase the land in 1733. He registered a complaint with provincial authorities asking that Brodhead's land warrant be revoked, and he and Brodhead attended a lengthy hearing in Philadelphia on March 27, 1737. Present at the hearing were Corse Urum, an interpreter, and Lapowinza, one of the Lenape chiefs, who submitted a petition asking for Brodhead's land warrant to be revoked. Lapowinza stated that Nicholas Depui had been a trustworthy, loving friend who had prevailed upon him and five other Native Americans to sign the petition.

The proprietor responded that it would be necessary to walk out the distances of deeds signed by Indians to the late proprietor, William Penn. Lapowinza agreed, but stated it was his "desire that it should be done, but that some other Indians were against doing of it, meaning Nutimus

and the Jersey Indians [who had] lately come over and settled near the Durham Iron Works." Hearings such as these played into the hands of the sons of William Penn, who were not as honorable as their father in dealings with Native Americans. John and Thomas Penn were greatly swayed by William Allen, who had already laid claim to 10,000 acres of land in Minisink country, disregarding the fact this was Lenape land. On September 19, 1737, the start of the infamous Walking Purchase began.

Doubtlessly, others had arrived before Brodhead. His 1735 petition asked for "600 acres of land lying above Pahequalen Mountains on Analomink Creek, being a place where one John Mathers, an Indian trader, long since built a cabin." Peter LaBar, a French Huguenot newly arrived in the port of Philadelphia, is said to have arrived in the area and built a log house on what is now Main Street in Stroudsburg. In 1930, the town staged a bicentennial recognizing LaBar's pioneer efforts. Although LaBar reportedly possessed a Native American deed, it has never been discovered. Since the proprietors of Pennsylvania recognized deeds issued only by the province, Daniel Brodhead is officially acknowledged as the first permanent settler of the Stroudsburgs.

Brodhead developed a close relationship with visiting Moravian missionaries, who often stayed at his home while en route to their destinations in the wilderness. Their mission stations extended from Bethlehem to as far away as Dutchess County, New York. Count Zinzendorf, founder of the Moravian colony at Bethlehem, visited Brodhead Manor in 1742. Brodhead and his wife, Hester, soon became members of the Moravian congregation. He donated 3.5 acres of land to build a mission church and a log parsonage on the west side of Brodhead's Creek, where they remained until 1755. Daniel Brodhead died in Bethlehem a few short months before the French and Indian War caused destruction of the mission and devastation throughout the settlement.

Like Daniel Brodhead, Jacob Stroud descended from an English family. His father brought his family of nine children to Smithfield Township and placed young Jacob as an apprentice to Nicholas Depui. He grew up with the family and served his apprenticeship until age 21, when he enlisted as a private in the French and Indian War. Returning from battle, he married Nicholas Depui's granddaughter, Elizabeth McDowell in 1761, with whom he had three sons and nine daughters. Shortly after the war, he built a large stone house, near the site where the Sherman Theater building now stands. Here, he and Elizabeth raised their large family. As the Revolutionary War arrived, the Smithfield Company formed in 1775, with Jacob's soon attaining the rank of colonel. His large stone home became Fort Penn, which operated as a supply distribution and trade center as well as a military post and a make-shift training camp.

After the war, Jacob's enterprising spirit soon led to his community on the west side of Brodhead's Creek becoming known as "Stroud's town." His eldest son, John, was disinterested in continuing the family business, so Jacob summoned his son Daniel, an Easton attorney, to continue the enterprise. Daniel Stroud, who was born on May 22, 1772 in the large stone house, acceded to his father's wishes. He proved to be as astute a businessman as his father was, laying out more lots and bringing to fruition the establishment of Stroudsburg.

Even before the official founding of Stroudsburg, the settlement of Dansbury seemed to have lost its identity, becoming known as "the village across the stream." An opportunity arose in 1854 that greatly changed its status. When the Delaware, Lackawanna, and Western Railroad needed a link to connect with Warren County, New Jersey, Stroudsburg residents objected, and the village on the east provided the needed right-of-way, with the stipulation that every passenger train should make a stop there. The 1856 arrival of the railroad changed the quiet farm community into an industrial center and led to East Stroudsburg's acquiring its own identity on May 23, 1870. Current place names such as Dansbury Park, Dansbury Terrace, and Dansbury Depot reflect the history of the settlement.

Today, only a bridge across the Brodhead Creek divides them, but the towns are distinct municipalities with separate school systems. At times divided by football rivalries, the Stroudsburgs have united through times of war, fire, pestilence, and flood. They have survived; they will prevail; come what may.

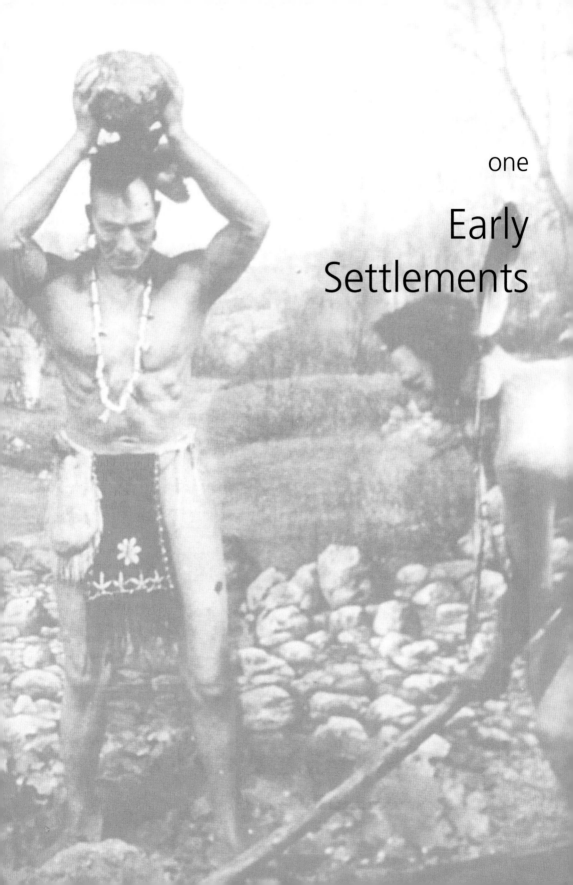

Early
Settlements

At the Delaware Water Gap, the Indian Head on Mount Tammany serves to remind us of the first inhabitants of the area. Mt. Tammany is on the New Jersey side of the Delaware River. When the first white settlers arrived, the Minsi tribe of the Lenni-Lenapes inhabited the region. The new settlers and Native Americans coexisted peaceably for many years. Historically, the river was a major highway for travel by canoe and other small craft. Today, Routes 80 and 611 flank the gap and provide the primary access to the Poconos.

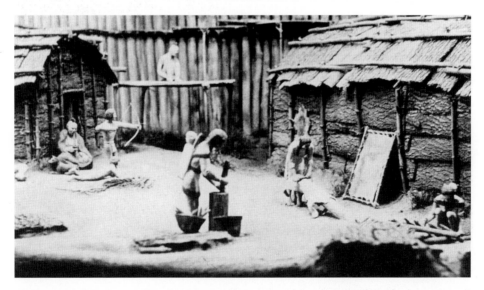

The Lenapes of the Poconos lived in homes called wigwams that were round or square in shape, with their framework composed of saplings. Sides of wigwams were covered with bark or corn husks, and a smoke hole through the roof provided for winter months when a campfire was needed for cooking and warmth. (Courtesy of Dr. Mary Knepp.)

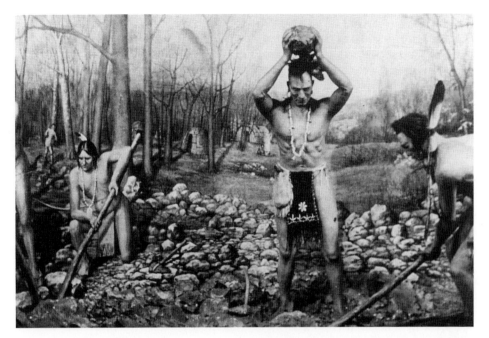

Thomas Knepp's carefully recreated scene depicts a flint quarry. Flint arrows were most important to the Lenape, for their survival depended upon the hunt and using the skillfully shaped arrows made from flint. Flint was also important for making fire. (Courtesy of Dr. Mary Knepp.)

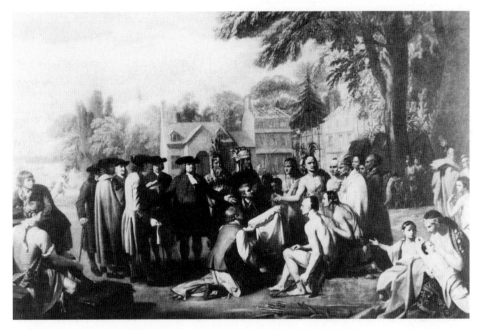

The "gentle Quaker," William Penn, treated the Native Americans with respect, realizing he had settled upon their land. His dealings with them were considered so fair that the "original people" called him "Brother Onas." Penn died in 1719, but his memory with the Lenapes was so great that they did not rebel until 1755, in spite of the injustice of the notorious "Walking Purchase" of 1737.

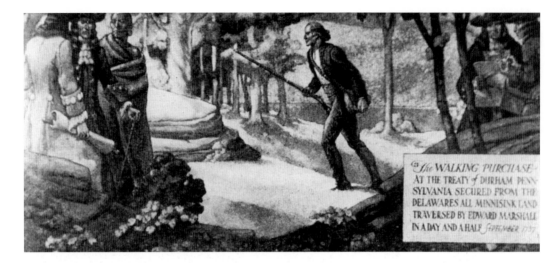

"The WALKING PURCHASE AT THE TREATY of DURHAM PENNSYLVANIA SECURED FROM THE DELAWARES ALL MINNISINK LAND TRAVERSED BY EDWARD MARSHALL IN A DAY AND A HALF *September 1737*

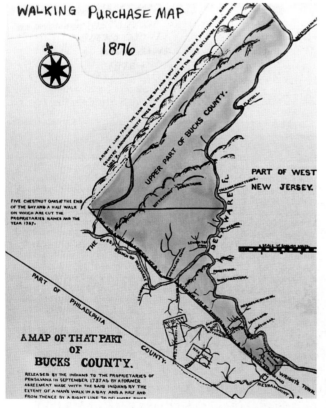

WALKING PURCHASE MAP

1876

PART OF WEST NEW JERSEY.

UPPER PART OF BUCKS COUNTY.

FIVE CHESTNUT OAKS AT THE END OF THE DAY AND A HALF WALK ON WHICH ARE CUT THE PROPRIETARIES NAMES AND THE YEAR 1737.

PART OF PHILADELPHIA COUNTY.

A MAP OF THAT PART OF BUCKS COUNTY.

RELEASED BY THE INDIANS TO THE PROPRIETARIES OF PENSILVANIA IN SEPTEMBER 1737 AS BY A FORMER AGREEMENT MADE WITH THE SAID INDIANS BY THE EXTENT OF A MANS WALK IN A DAY AND A HALF AND FROM THENCE BY A RIGHT LINE TO DELAWARE RIVER

WRIGHTS TOWN

NESHAMINY

Above: Portrayed by George Gray, this mural of the Walking Purchase depicts Edward Marshall, one of the trained, carefully instructed athletes conducting the walk. Marshall walked at a furious pace, swinging an ax for better stride. He was accompanied by surveyors and Native American escorts, who, angered at the speed, stormed away from the so-called "walk."

Left: This map of the Walking Purchase of 1737 shows the route of the "walk" from Wrightstown, Pennsylvania to an area near the town of Jim Thorpe. The shaded area indicates territory gained—about 1,200 square miles—which included prime hunting grounds of Minisink land along the Upper Delaware. Compounding the injury to the Lenapes, surveyors were instruct ed to draw survey lines in a northeast direction in order to acquire more land.

Opposite, below: Daniel Brodhead built his log home on this location, naming it Dansbury Manor. He died several months before the French and Indian War ravaged the area. On December 11, 1755, his sons held off a war party of about 200 Lenapes for almost eight hours until they retreated, carrying off their dead and wounded. Today, Pocono Medical Center stands on the site.

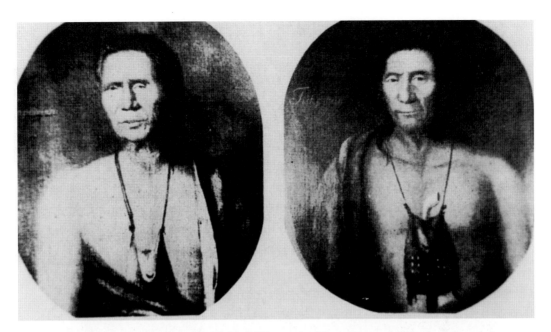

Early artist Gustavus Hessilius painted this 1735 portrait of Lapowinza and Tishcohan, the two Lenape chiefs who signed the release for the Walking Purchase. The chiefs are adorned with blankets and their tobacco pouches. John Penn commissioned the portrait, and it is believed it was done to gain their favor. The name Lapowinza translates to "going away to gather wood," and Tishcohan means "He who never blackens himself."

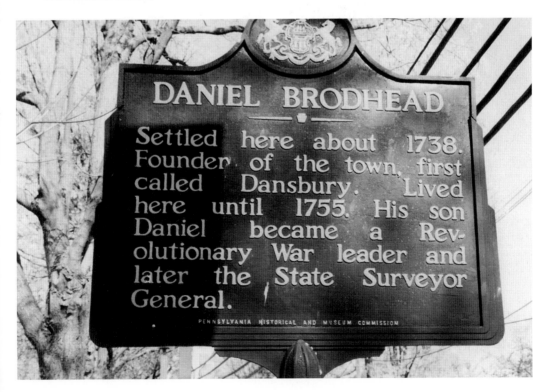

DANIEL BRODHEAD
Settled here about 1738. Founder of the town, first called Dansbury. Lived here until 1755. His son Daniel became a Revolutionary War leader and later the State Surveyor General.

PENNSYLVANIA HISTORICAL AND MUSEUM COMMISSION

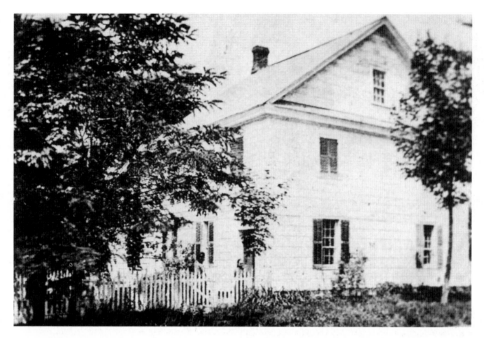

Gray siding covers the log walls of the oldest house still standing in East Stroudsburg. For well over 250 years, the descendants of Daniel Brodhead have lived here, descending from the line of Garrett Brodhead, Daniel's son. Garrett settled here on his father's farm when he returned home from Revolutionary War service. (Courtesy of Gail and Ed Flory.)

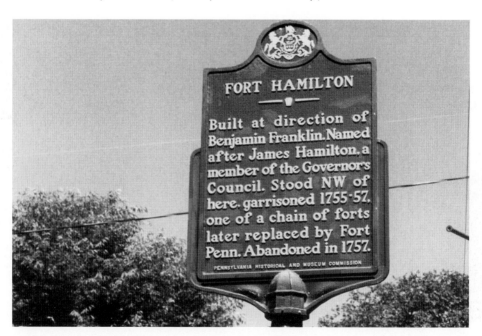

Following a series of Native American attacks, colonials built this fort some time between mid-January and February 1, 1756. Near what is now Stroud Mansion, the stockade covered the grounds of the Lutheran Church and reached southeast to what was later the Indian Queen Hotel.

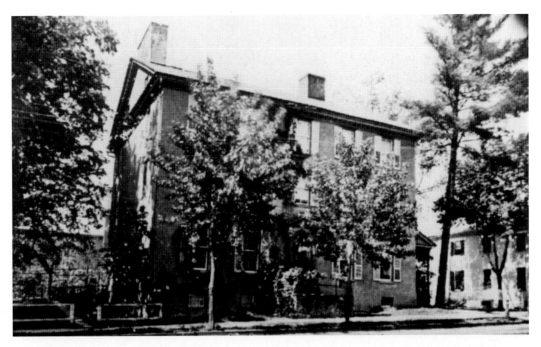

In 1795 Jacob Stroud built this large Georgian-style stone house, now covered with stucco, for his son John, who lived there for several years, but eventually decided to move to a farm. In 1800, his brother Daniel moved into the home and took over the family business.

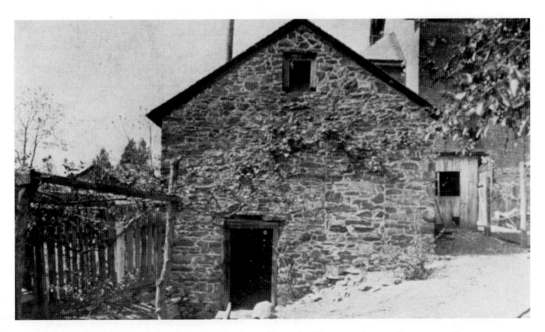

The old spring house behind Stroud Mansion still stands. However, it now lies on an adjacent property owner's land and serves as a garage.

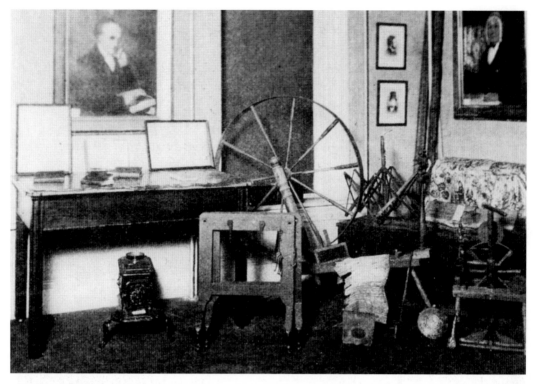

The Museum Room at Stroud Mansion, as seen here in 1927, displayed memorabilia and portraits of the Stroud family and other early settlers. Of special interest in the display was Daniel Stroud's Hunt breakfast table with a dark marble top.

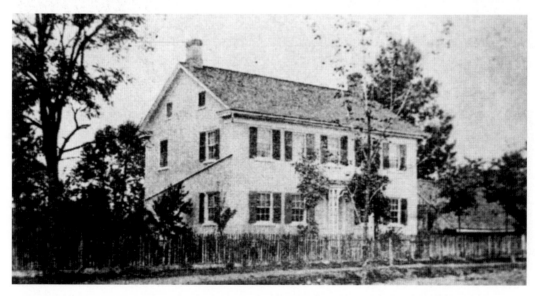

The oldest stone residence in East Stroudsburg was built for Hannah Stroud Starbird, wife of John Starbird. Located at 186 Washington Street, the house faces Starbird Street. (Courtesy of Charles Garris.)

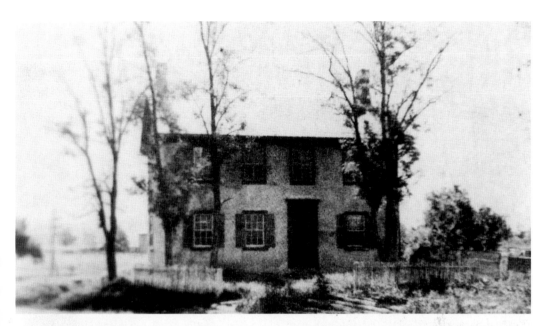

Jacob Stroud built this house for his daughter, Deborah Stroud Burson, wife of James Burson. Pocono Metal Products used the building, located at Burson and Harris Streets in East Stroudsburg, as an office for many years.

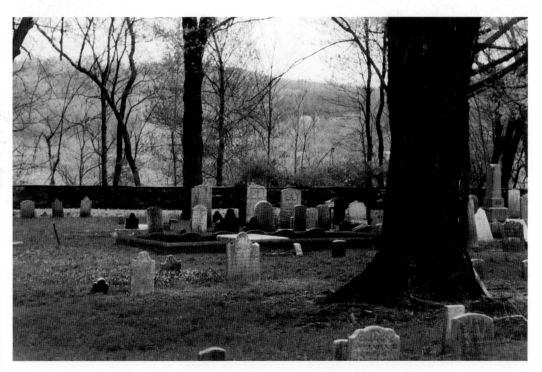

Jacob Stroud and his family are buried in the Moravian Mission cemetery on Lower Main Street. Their monuments lie within the flat rectangular area slightly left of the large tree. Records show that settlers were buried here as early as 1755, but markers do not indicate their names.

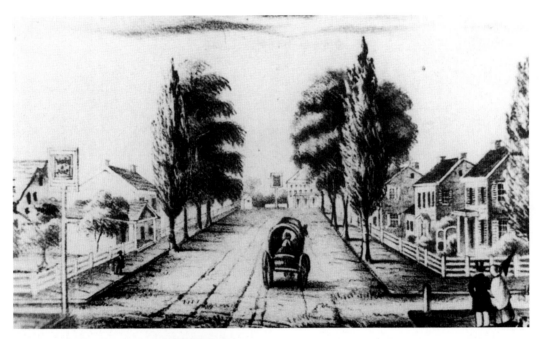

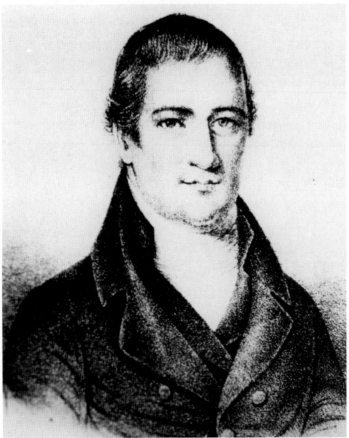

Above: This view of Stroudsburg in 1845 shows Fort Hamilton in the background. The relatively wide street reveals the wisdom of the planner in his vision of further expansion.

Left: When Jacob Stroud died in 1806, his second son, Daniel, inherited the land and furthered the idea of founding a town. In 1810, he sold additional lots and worked toward the town's incorporation. Five years later, an act officially chartered Stroudsburg as a borough.

two

Scenes of
Stroudsburg

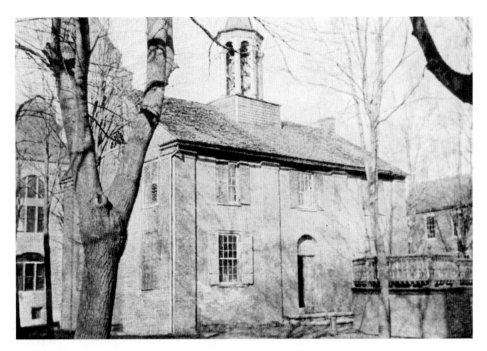

When Monroe County was created out of Northampton and Pike Counties in 1836, a new courthouse was needed. The selection of Stroudsburg as the county seat was decided when it won the vote over rivals Dutotsburg (Delaware Water Gap) and Kellersville.

In the 1880s, a number of Molly McGuires were held in the jail of the old courthouse while waiting to be tried for rebellious activities in the coal regions.

By 1890, the county needed a new courthouse, and the old one was sold to Andrew J. Hill for $5. The brick building was cut into sections and moved. A legend persists that the courthouse was rebuilt and stands on Ridgeway Street in East Stroudsburg.

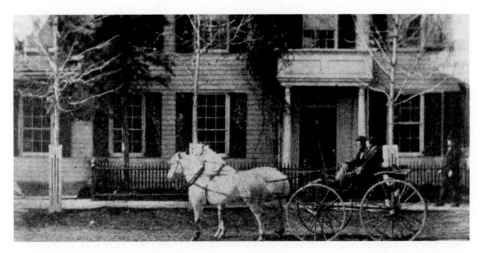

Stogdell Stokes, founder of Stokes Mill in Stroud Township, lived in this house located at Green (now Eighth) and Main Streets where the Regency Loan building now stands. A community leader, Stokes helped bring about the formation of the county and the establishment of Stroudsburg as the county seat.

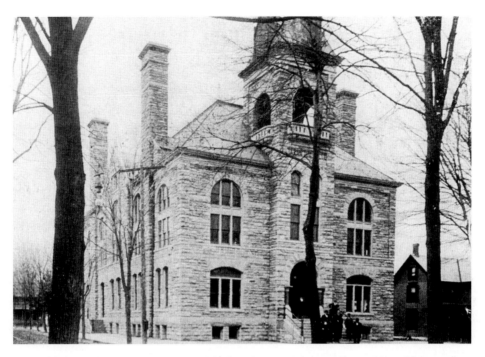

The "new" courthouse was seven years old when this 1897 photograph was taken. That was the same year the courtrooms and judges' chambers were lit by electricity. Today, the circle in front of the courthouse indicates where the old 1836 courthouse had been removed.

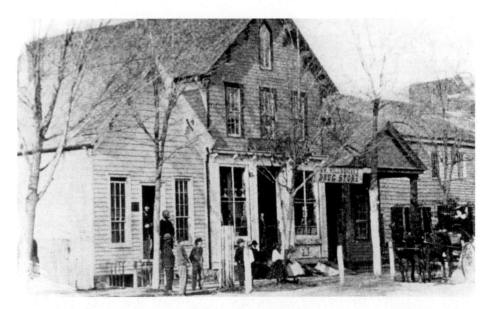

Main Street in 1865 included the following buildings from left to right: office of A. Reeves Jackson, Hollinshead's Drug Store (now Kresge-LeBar's Drug Store), law office of Samuel S. Dreher (later president-judge), and William Dean property (later the site of J.J. Newberry's store). The figure in the doorway is Dr. A. Reeves Jackson, who is featured as "The Doctor" in Mark Twain's Innocents Abroad.

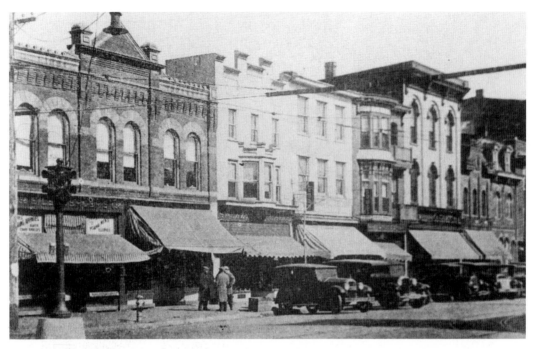

The same part of Main Street as previous page is seen here in 1927. Stores from left to right were as follows: Eilenberger's Clothing and Wirt D. Miller's grocery, Eilenberger and Huffman law offices (second floor), Sweazy and Michaels, LeBar's Drug Store, United Cigar Store Co., Newberry's, Candyland, Bell's Insurance Office, and E.B. Holmes law office.

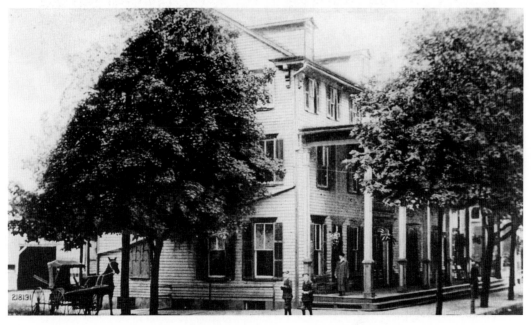

The ever-handy horse and buggy at the Washington House provided transportation for guests. Today, where the hotel once stood, modern vehicles line the parking lot of Kentucky Fried Chicken.

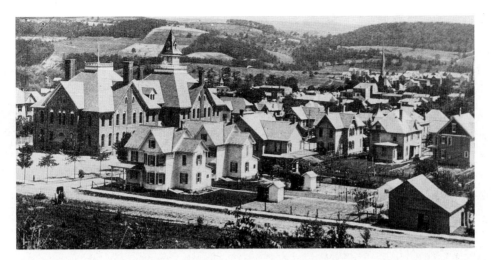

This 1896 view of Stroudsburg shows a fairly built-up town, but "outhouses" reveal the lack of indoor plumbing.

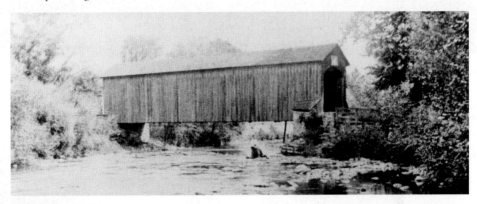

The towns had their share of covered bridges. This bridge over McMichael's Creek was replaced long ago by the Broad Street Bridge.

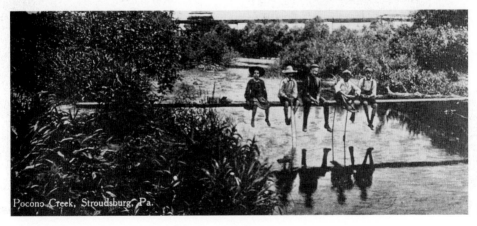

A footbridge sufficed for crossing the Pocono Creek, where these young lads enjoyed fishing, and perhaps "playing hooky."

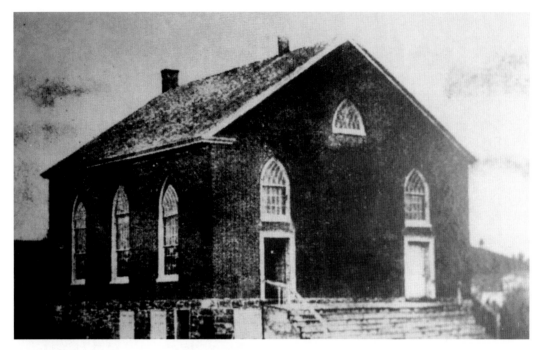

Jacob Stroud donated land for the old Presbyterian church on Sarah Street, built in 1834. Church members worshiped there until construction of the new First Stroudsburg Presbyterian Church on Main Street was finished.

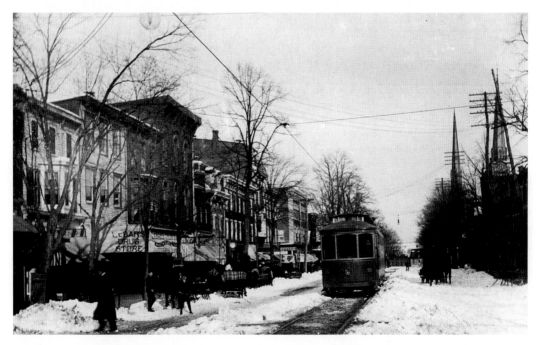

Snowstorms did not deter the running of the electrified trolley on this winter day. Twin spires of the Methodist and Presbyterian churches are viewed on the right. (Courtesy of Kresge-LeBar.)

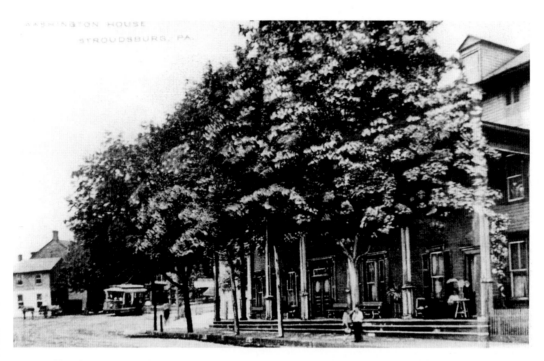

Fifth and Main Streets show a remarkable change today compared to when the old trolley rounded the bend.

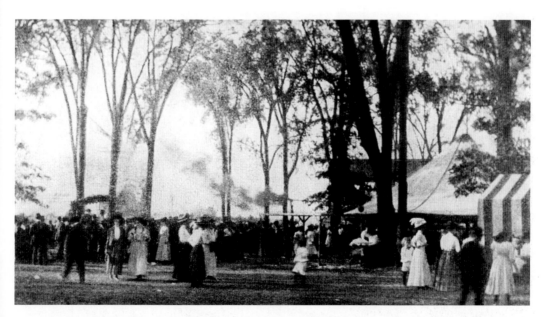

"Hi, Ho, Come to the fair!" This picture from a 1910 advertising card announced the 38th annual Monroe County Fair, although fairs were conducted since the time of the Civil War.

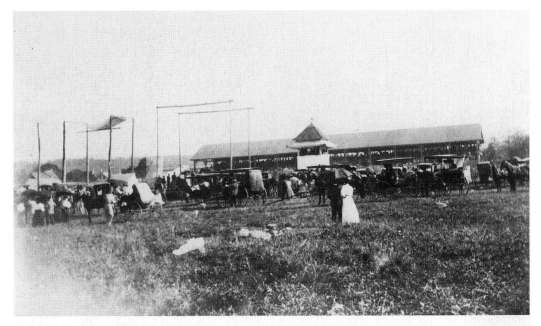

Circuses provided one of the major attractions of the fair. Baked good contests and livestock judging were offered, as well as perhaps the chance to bid to share a box lunch with a pretty girl! The fairground was located on West Main Street on the grounds of the present Stroudsburg Area School District. (Courtesy of Kresge-LeBar Drug Store.)

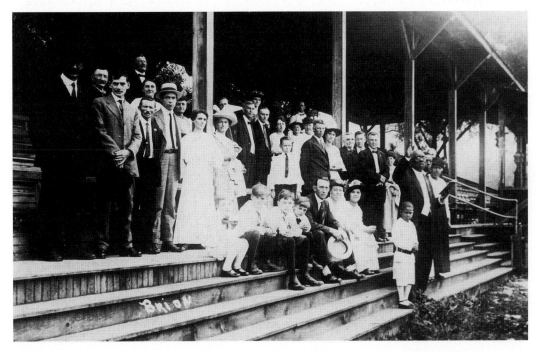

Watching from the grandstand of the old fairground, people could see horse racing and Wild West shows. If a slower pace was desired, the fair presented walking races. (MCHA photograph.)

A horse with a blanket decorated with "Cook" pulls a hay-covered wagon as it passes by the Malta Temple building. Passersby stroll by or chat in front of stores that occupy the lower level. Flowerland, and Pocono Sew and Vac now occupy the building.

Lackawanna Trail, more commonly known as Route 611 today, provided a quite different view from the busy highway it has become.

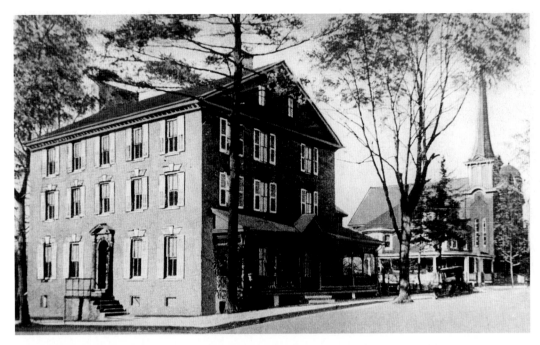

The Stroudsburg Civic Club purchased Stroud Mansion, once the home of the Strouds, after it fell into disuse. For years known as the Community House, it initially housed a public library and a woman's club. Its porch has long since been removed and it serves today as the home of the Monroe County Historical Association. Seen on its right is St. John's Lutheran Church, built in 1869.

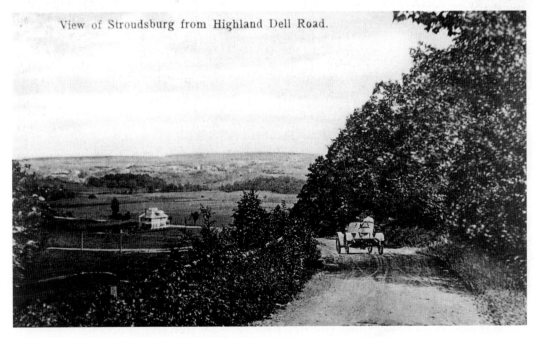

A pastoral scene of Stroudsburg is viewed on this image from days of old.

In yesteryear, drivers found easy parking on the 800 block of Main Street with no parking meters. However, some parallel lines were there to guide them.

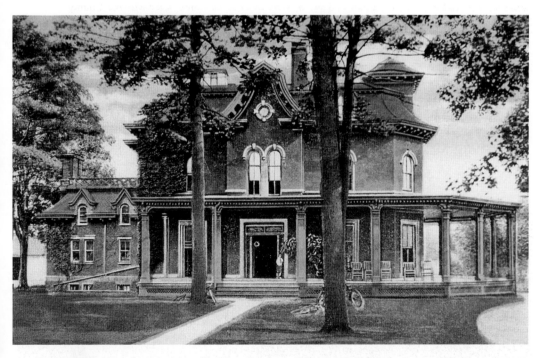

YMCA officials and town citizens bought a handsome Victorian building for use in 1914. It was known as Harriet Hall. The old building was torn down and replaced in 1955. Sebastian S. Kresge, of chain store fame, made possible the construction of a new YMCA.

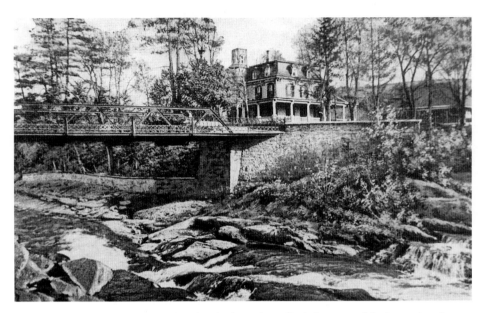

An early scene, looking east toward McMichaels Bridge, afforded a view of the home that the VFW later occupied. Nearby, the Wilkes-Barre and Eastern Railroad built its station.

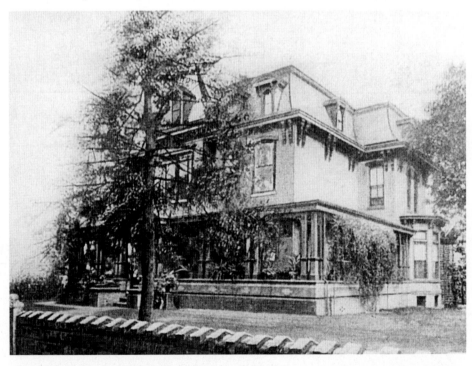

Recognize this home? Thomas Kitson, owner of the Stroudsburg Woolen Mills, built it, and today the stone wall that bordered its expanse of lawn is gone. Hoola Hoops now stands in the foreground, and Club Vogue occupies the house.

three

Views of
East Stroudsburg

This 1896 photograph of East Stroudsburg shows a view from the heights on today's Route 191 leading to Cherry Valley.

Formerly a part of Smithfield Township, East Stroudsburg was incorporated as a borough on May 23, 1870. Isaac T. Puterbaugh, Charles Durfee, Miles L. Hutchinson, Alexander Loder, Samuel P. Smith, and William N. Peters acted as its first elected council members. They first met and continued to hold future council meetings in the Analomink Hotel, where borough hall now stands. They promptly set about to name the first streets: Washington, Brown, Courtland, Crystal, Analomink, and Kistler Streets.

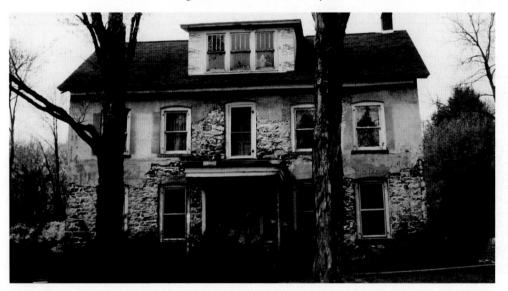

Robert Brown lived in this house built by his grandfather in 1799. Robert led the movement to bring the railroad to East Stroudsburg by giving the Delaware, Lackawanna, and Western Railroads (DL and W) land for a mere dollar to secure the needed right-of-way. He was an abolitionist, and the home served as a way station for the underground railroad. Slaves were reportedly hidden in a cistern by the house until they could make their way to Canada.

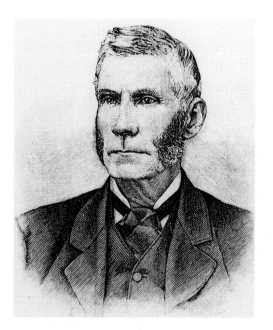 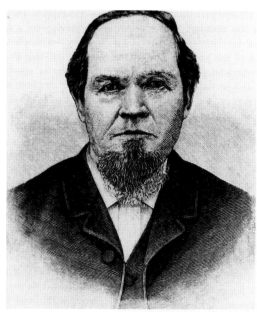

Above, left: Isaac T. Puterbaugh acted as the first elected chief burgess of East Stroudsburg shortly after the town was incorporated on May 23, 1870. Serving over 50 years with the DL and W, he contributed greatly to the growth and prosperity of the town.

Above, right: Prosperous merchant Alexander Loder served as one of the first burgesses of East Stroudsburg. Additionally, he was a member of the school board, a justice of the peace, and postmaster of the borough.

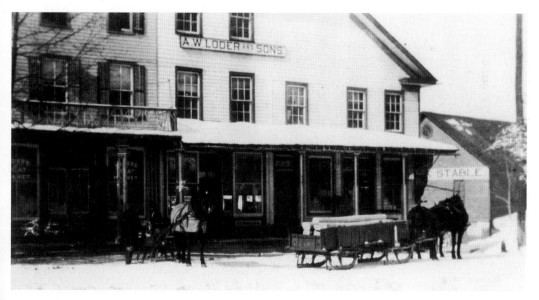

When it snowed, a sleigh would suffice for delivering goods to and from Loder's Store. A roadway long ago replaced the stable. With groceries, dry goods, and a stable nearby, Alexander Loder's store became known as "the busy corner" at Crystal and Analomink Streets. He conducted his business here until he died, at which time his son took over. Loder's and several other adjacent stores vanished in the fire of 1978.

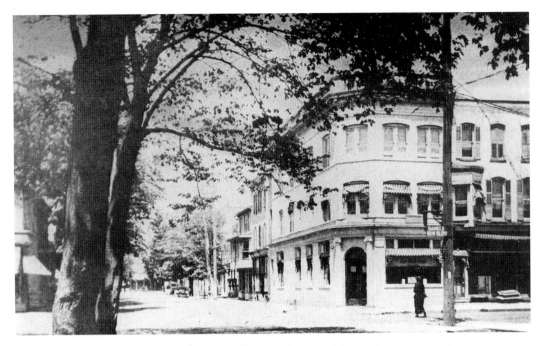

East Stroudsburg's first bank was chartered in 1889. Over the years, it has undergone many changes in outside design and in management. Since 1970, the bank has been reorganized as Pocono Bank, Northeastern Bank, and presently, PNC. It still contains its original massive vault from the late 1800s.

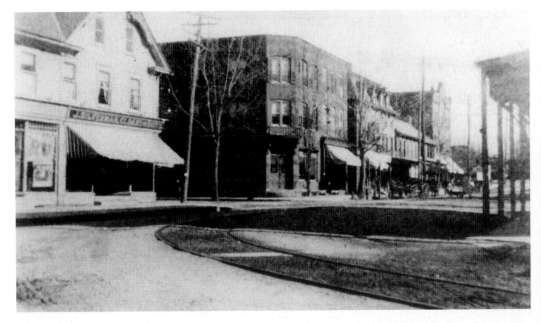

Today this busy intersection looks quite different from when this postcard was published in the early days. There was no need for a traffic light then. Gone are Silverman's first store and the porch extending from the building on the right.

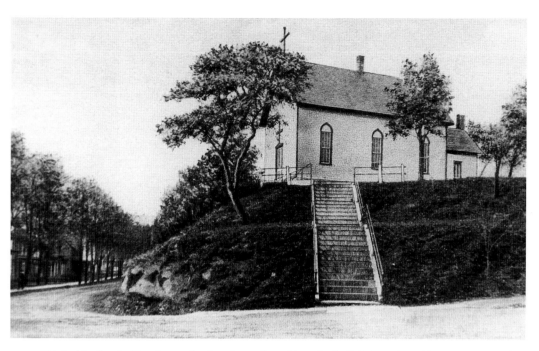

Old St. Matthew's Church was the first place of worship to be built in East Stroudsburg. Constructed in 1868, it was situated on Brown Street on a right-of-way donated by the DL and W railroad. It came about because the railroad wanted to provide a church for its workers, who were mostly Irish-Catholic. It was razed in 1970 in order to widen Brown Street.

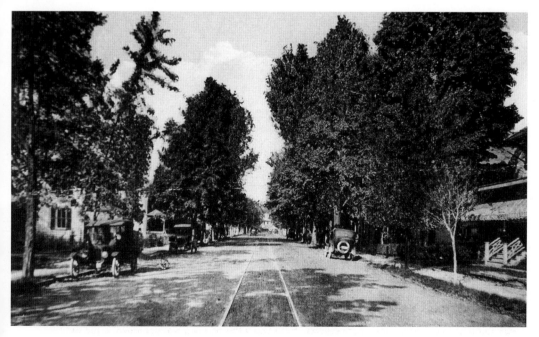

Lower Washington Street ran both ways until a flood in 1955 when a new bridge was built and several streets became one-way.

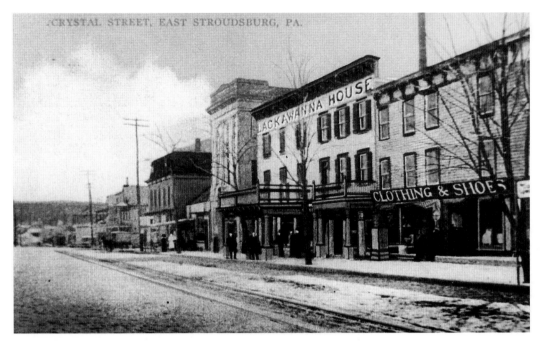

An early view of Crystal Street looking south shows the Belgian block paving stones alongside trolley tracks and Lackawanna House with its porch, long since removed.

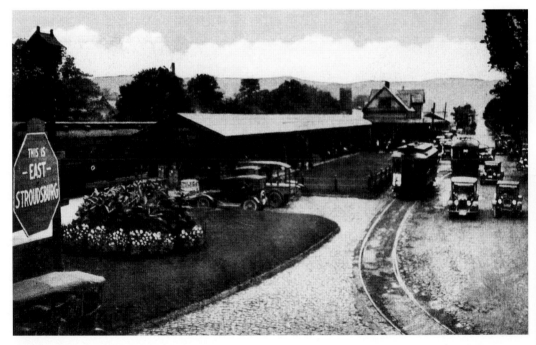

A sign amid flowers and a well-manicured lawn by the depot introduces visitors to the town in the busy tourist season. Plenty of transportation was available to take them to the many resorts that blossomed as a result of the railroad's convenience.

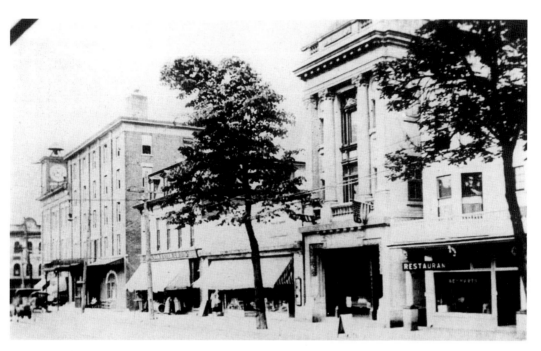

This view of Crystal Street in about 1912 revealed the town had gained another bank, Monroe County National, built a dozen years earlier. Down the street, the Fenner building's clock reduced the need to check a watch. Today, Mellon Bank does business in the old bank building, but has made plans to move to the Pocono Plaza shopping area.

This scene of what is today's Route 209 North reveals much narrower streets and long-gone buildings.

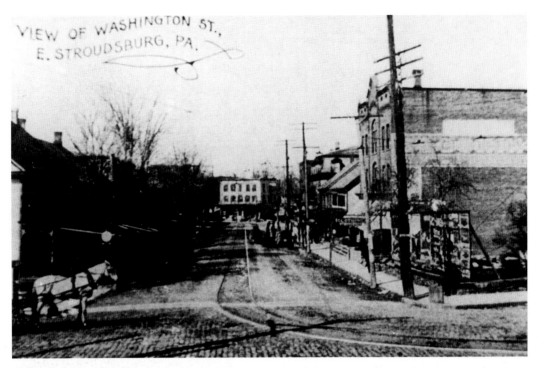

Rounding the corner from South Crystal Street, a dray horse advances forward toward trolley tracks. Seen in almost mid-center of the photograph, the white building gives a view of what is today Rudy's.

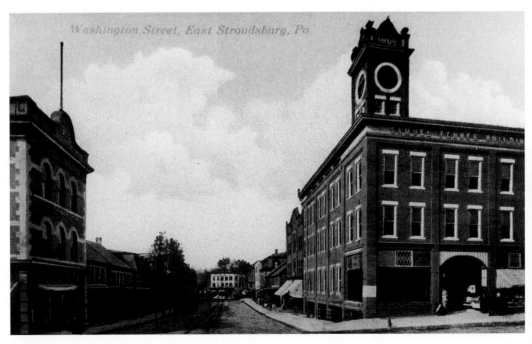

A later view of the same scene as above shows the Henry building (left) built in 1909 and the Fenner building (1910) in place.

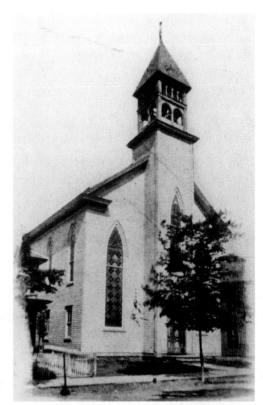

Right: In early days, Methodist church services were held in private homes and later in the Academy of Music, where the Pocono Cinema now does business. This building, East Stroudsburg's first Methodist church, was built in 1875. It stood where the Wes Freedman store later had its business. Members worshiped here until the new church was built up the street in 1923.

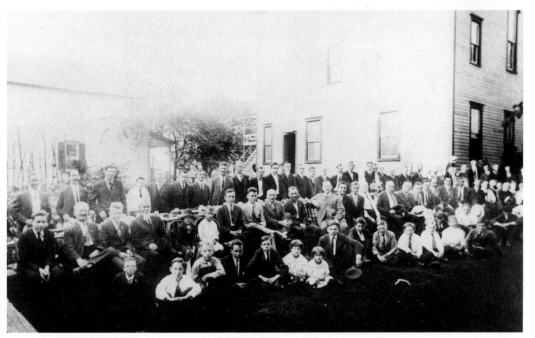

The Men's Brotherhood of the Methodist Church poses for this 1915 picture of their group. The photograph provides a side view of the old Methodist church.

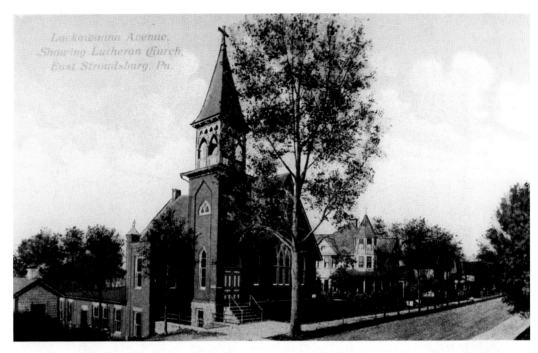

The Lutheran church on Lackawanna Avenue was built in 1896. Until then, church members conducted worship in Bossard's Hall at the corner of South Courtland and Washington Streets.

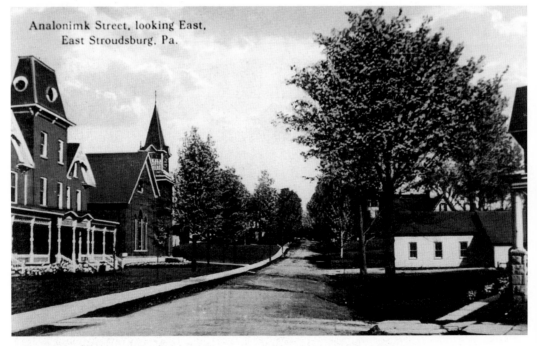

An old postcard shows Analomink Street in East Stroudsburg, with the Alexander Loder home, now a senior citizens' center, pictured on the far left. The next building is the Presbyterian church, destroyed in a 1967 fire.

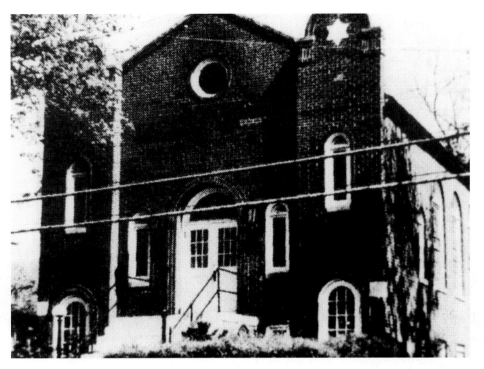

The first Temple Israel was located on Brown Street, near what is now K-Mart. It remained there from 1923 until 1963, when the new synagogue was built on Wallace Street and Avenue A in Stroudsburg. Before the original building was constructed, religious services were held in private homes and in a hall at the Henry building on Crystal and Washington Streets.

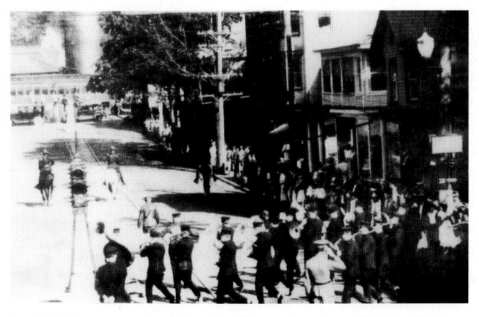

A traffic light hovers over trolley tracks as this military parade marches up Washington Street toward the train. (Courtesy of Don and Judy Lee.)

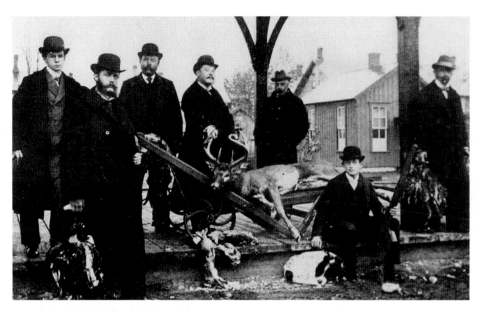

Not to be viewed by the faint of heart, this 1896 picture of "a one week's hunt" was photographed at the railroad station. It was taken by dentist/photographer Jackson Lantz, who was noted for his elaborate, decorative framing of photographs.

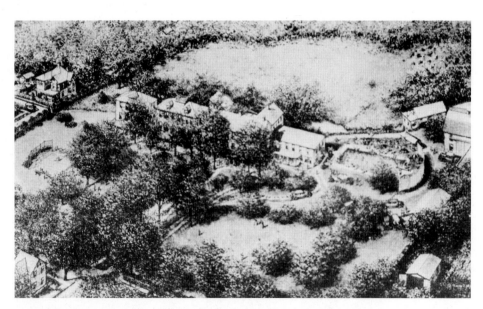

An aerial view of the Maplehurst Inn shows the vast area the resort covered. The East Stroudsburg Area School District bought 53 acres of its land in 1945, and today the high school stands on the property.

four

From
Stagecoach to
Automobile

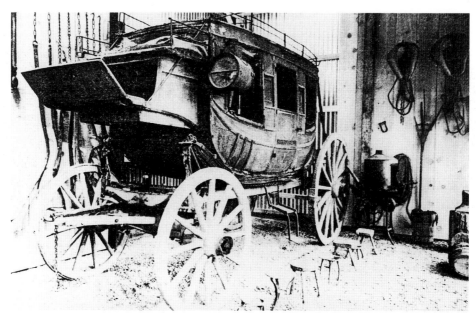

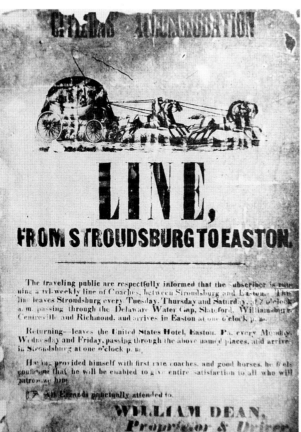

Above: Before the Delaware Valley Railroad was built, passengers and mail had to find other means to be transported north. This early stagecoach, called the "Hiawatha" and built in 1865, filled this need, traveling between the Stroudsburgs to Bushkill, Milford, and Port Jervis, New York. Its owner, John Findlay Watson, had been a coachman for Queen Victoria. His descendants donated the Hiawatha to the Pike County Historic Association, where it is on display. (Al Koster photograph.)

Left: In 1852, Billy Dean carried passengers and mail to points south, traveling the route at least three times a week. The fare to Easton cost $1.25.

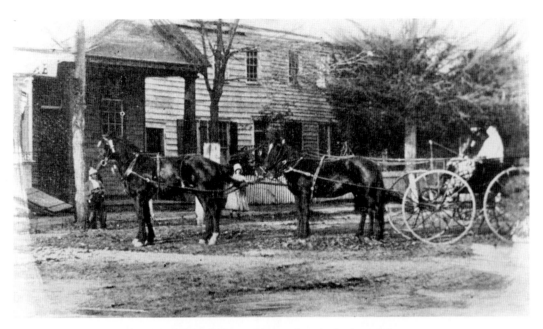

The "four-in-hand" reduced its team to two horses when the load was lighter.

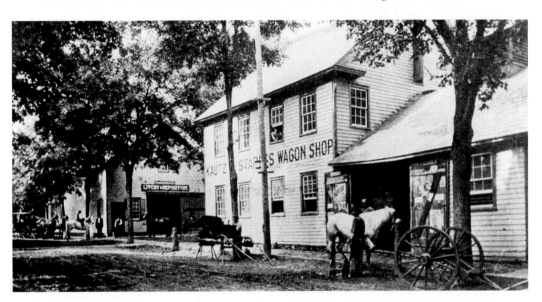

In addition to other services, Kautz and Staples, wheelwrights and blacksmiths, located at Ninth and Monroe Streets in Stroudsburg, rented horses and were a major supplier of horse blankets.

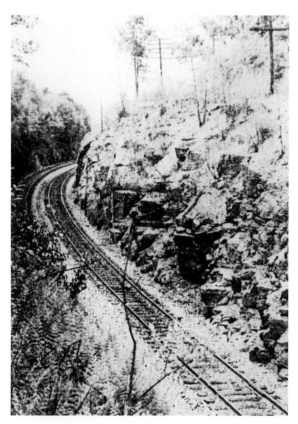

Left: In order to build the railroad, a path had to be carved through iron deposits of sheer rock, about 400 feet long and 40 feet high in some places. Irish immigrant workers who had escaped the Great Famine in Ireland achieved the monumental task in 1856. The area is known today as Forge Cut. (Courtesy of Geraldine MacLeod.)

Below: As this old postcard reveals, the Delaware, Lackawanna, and Western Railroad station in East Stroudsburg was often called the "Stroudsburg" station.

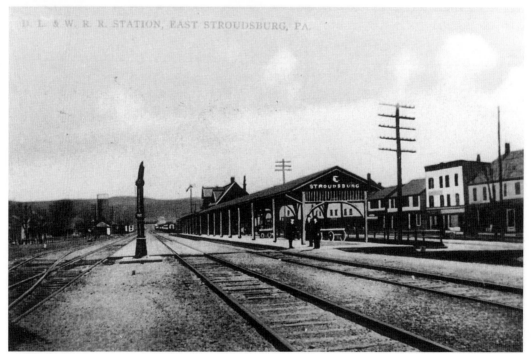

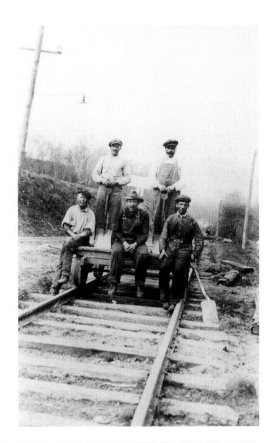

Right: The "Men of Iron," the railroad workers, toiled long hours at their strenuous tasks. (Courtesy of William and Betty Laise.)

Below: Train wrecks were common, particularly in the area of Forge Cut, and townspeople often flocked to the scene. (Courtesy of William and Betty Laise.)

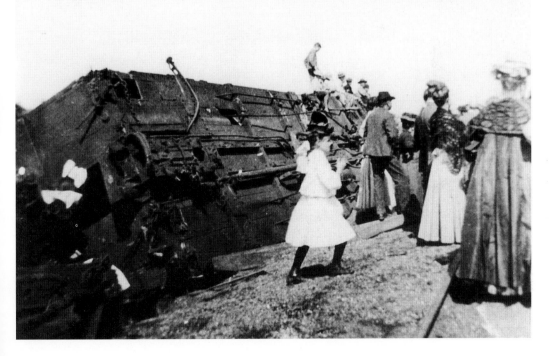

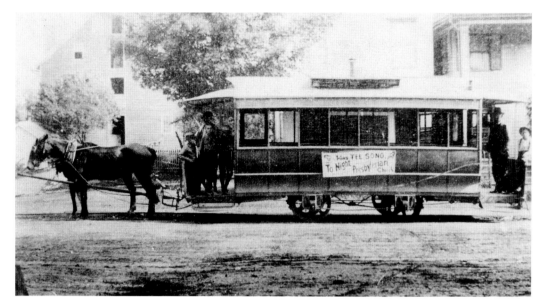

"Horsepower" had a different meaning in the 1800s. The Stroudsburg Passenger Railway developed its trolley system in 1870. Mules or horses pulled its first passenger cars and carried people back and forth from the East Stroudsburg's railroad station to Stroudsburg. Stoves provided heat in the winter. (MCHA photograph.)

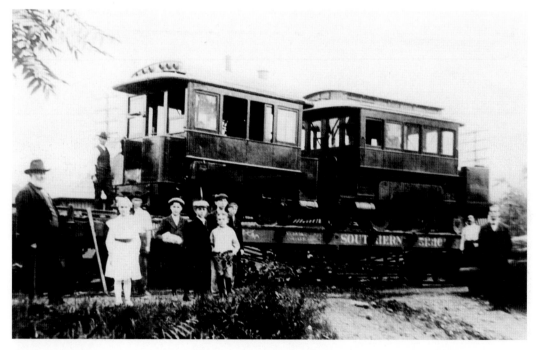

"Dummy" trolley cars arrive on a flatbed to be unloaded. From 1892 to 1910, an engine called the "dummy" pulled the cars. Adults pictured from left to right are: Frank Smith (holding a cane), Edward Smith (near car), and Frank Adams and Dr. Henry (on the right of cars). Children are identified only as the "Henry girl" and the "Reinhardt boys."

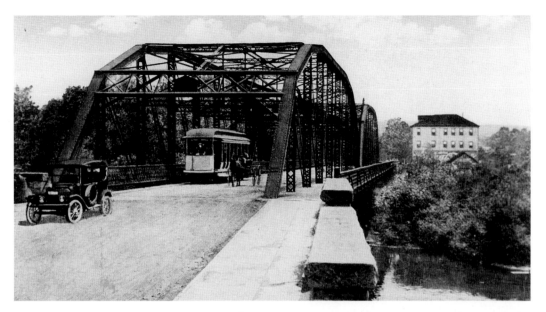

Horse cart, trolley, and automobile present a quaint, eclectic image of transportation as they cross the old State Bridge.

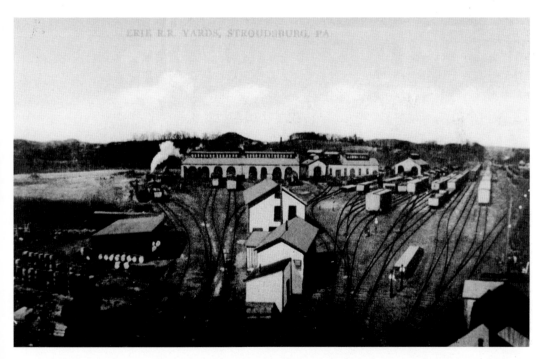

The Erie Car Shops repaired locomotives and freight cars, and installed air brakes and couplers. It was owned by and serviced the Wilkes-Barre and Eastern, and New York, Susquehanna and Western railroads. Katz's Scrap Yard in Stroudsburg now occupies the site. (Courtesy of MCHA.)

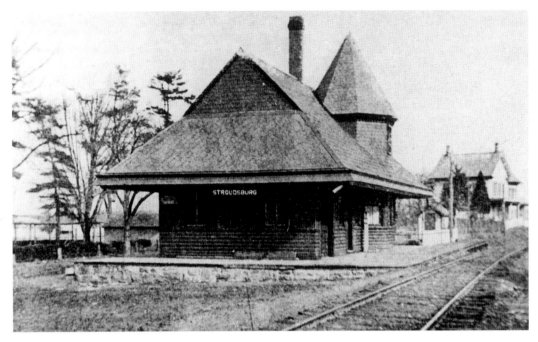

The Wilkes-Barre and Eastern Station opened in 1894 as a result of Stroudsburg's attaining the rail line. With limited passenger service, the line's principal function was transportation of coal. (Courtesy of MCHA.)

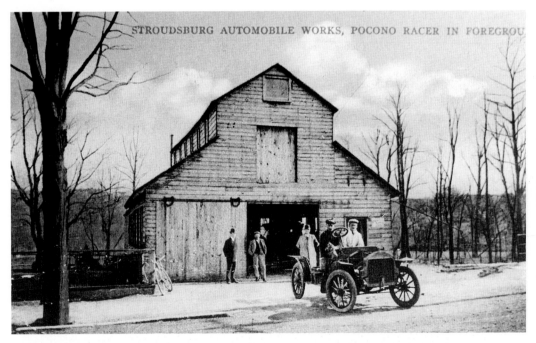

Clarence Stone owned the Stroudsburg Automobile Works, located on Main Street in Stroudsburg. The trio pictured in the racer, from left to right, are as follows: William Struble, Clarence Stone (plant owner), and Thomas Kitson (owner of Kitson Woolen Mills). Scholla Buick later owned the property.

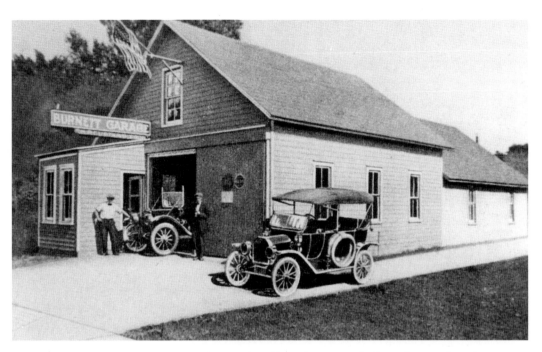

Burnett Garage, as seen in a 1915 photograph, sold Buick autos. It was located on Analomink Street in East Stroudsburg and owned by H.P. Custard.

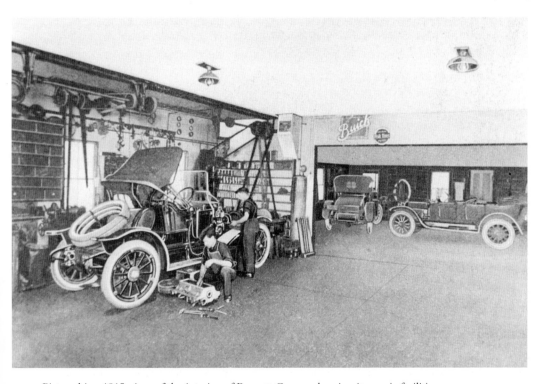

Pictured is a 1915 view of the interior of Burnett Garage, showing its repair facilities.

The most lavish automobiles stopped at the Indian Queen Hotel, which ranked, in its heyday, as one of the finest area hotels.

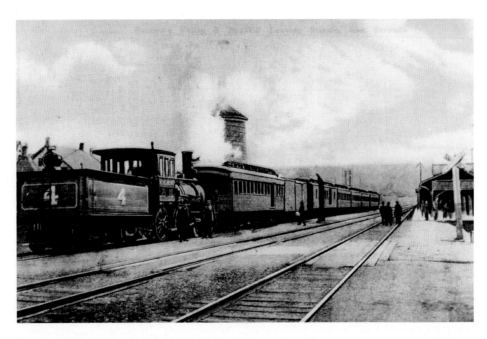

Delaware Valley Railroad's old Engine #4 made daily round-trips, carrying passengers and freight to Bushkill. It operated from 1901 to 1929. Lacking a turntable, the engine had to back-up the train to Bushkill.

MONROE MILLS

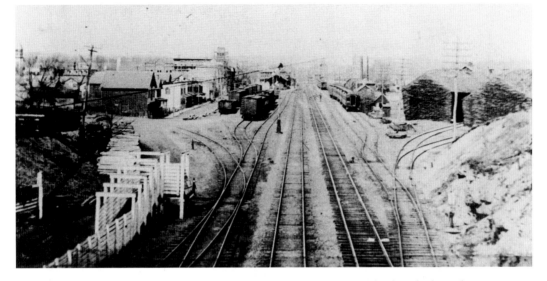

A view of the Kistler Street side of the railroad shows the various industries that have built up along its periphery. Earliest known as East Railroad Street, Kistler gained its name shortly after the borough was incorporated in 1870.

Historically, small industry developed first along the waterways, with gristmills and others taking advantage of waterpower. The advent of the railroad created a burgeoning of major industry in both towns. The tanneries, lumber mills, glass works, and larger mills first developed as a result of the convenience of shipping by rail.

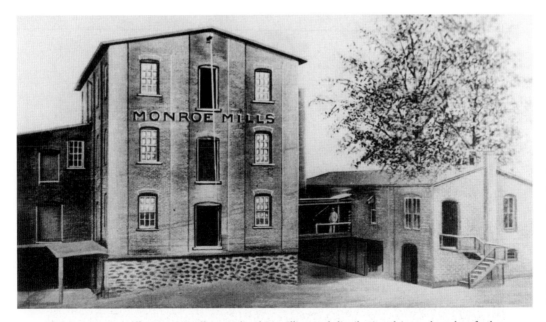

Founded by J.M. Wyckoff, Monroe Mills specialized in milling and distributing dairy and poultry feeds, as well as rye flour for the New York market. It often shipped three hundred carloads a year by way of the railroad. Once located on North Kistler Street in East Stroudsburg, it has since been torn down, but the Wyckoff residence still stands just above the mill site.

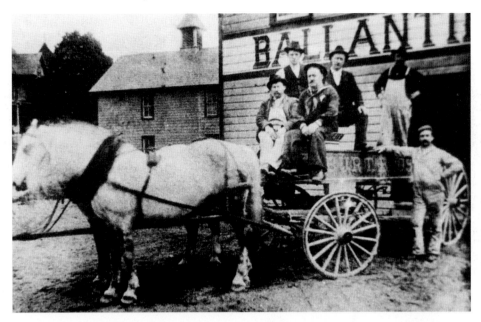

Burt Brothers Bottling delivered. Located next to the Wyckoff Feed Mill on North Kistler Street, it was organized in 1868. It bottled Ballantine beer, ale, and, porter, and manufactured soft drinks. Horse-drawn wagons made local deliveries, and the railroad shipped its products to distant markets. Pictured from left to right are: Joseph Stettler, G. Dutt, James Deamer, George Lockery, George Parsell, and John T. Burt Sr.

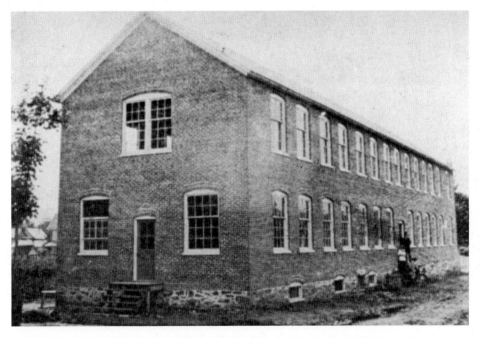

W.H. Gibbs and Company in Stroudsburg specialized in artistic cut glass. The Stroudsburg Industrial Club secured it as a new industry in 1910.

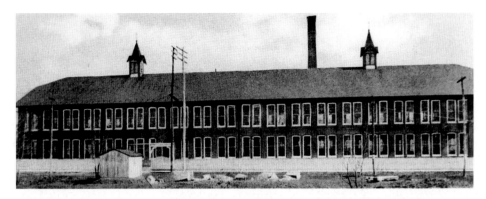

In 1884, John C. Ryle and his son-in-law, George B. Tillotson, built this silk mill in East Stroudsburg adjacent to the Interborough Bridge. William Gilbert bought the company in 1901, renaming it the William A. Gilbert Company. The plant, producing broad silks, had as its president A. Mitchell Palmer, who later became Attorney General of the United States under Woodrow Wilson.

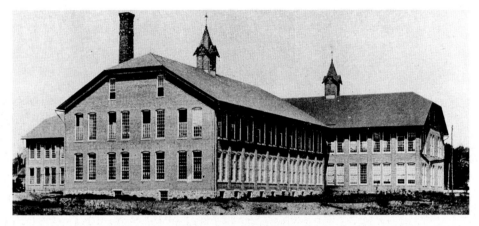

A rear view of the old silk mill shows its massive vault. Most recently known as Redmond Finishing, the building was destroyed by fire in 1994. Today the west side of Pocono Plaza, including the new Wal-Mart, embraces the area where the mill once stood.

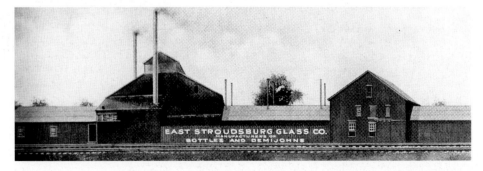

Milton Yetter (owner of the Delaware Valley Railroad) and William Burrows started the East Stroudsburg Glass Company, located on North Courtland Street, opposite Lenox Avenue. Early in the morning, it manufactured bottles, carboys, and demijohns, and at the end of the day produced novelties such as decorated glass balls, rolling pins, and glass canes.

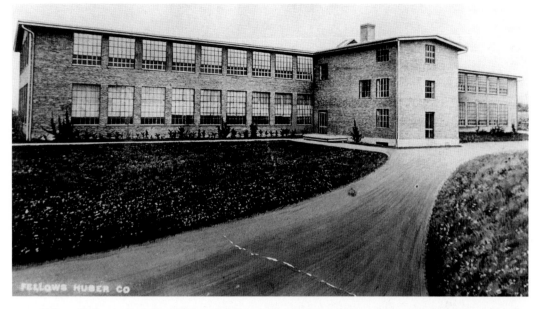

Fellows Huber in East Stroudsburg opened in 1913 with 80 employees. Located between Harris Street and the railroad, it was owned by A.C. Huber and C.L. Fellows. The mill produced about 10,000 yards of dress silks weekly.

International Boiler Works established its manufacturing plant in East Stroudsburg in 1886. Between 1908 and 1910, it assembled 25 Sharp-Arrow cars and raceabouts as a sideline. The plant closed in 1992.

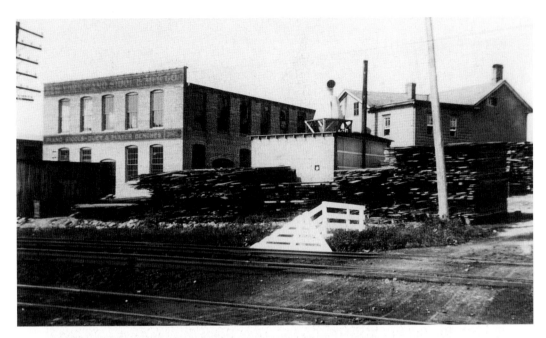

The New York Piano Stool Factory, located on the corner of Burson and Harris Streets in East Stroudsburg, began operations in 1913 with Chester G. Booth as its manager. With 33 employees, it manufactured one hundred piano stools and 25 benches daily. (Courtesy of Beulah McConnell.)

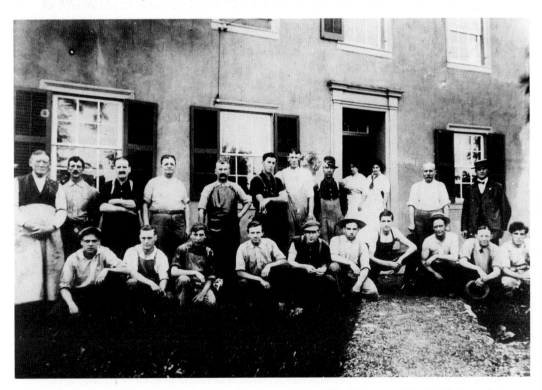

Employees of the Piano Stool Factory posed for this picture about 1914. (Courtesy of Beulah McConnell.)

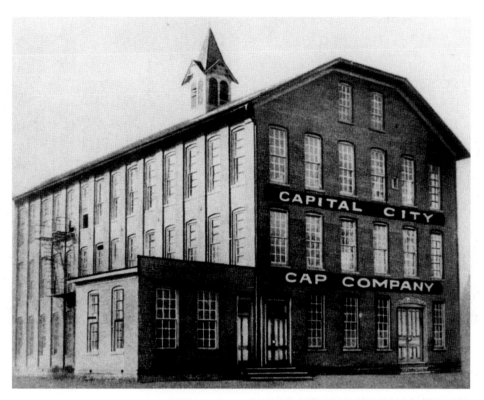

Once located where Pocono Plaza now stands, Capital City produced bottle caps. It was established in 1910.

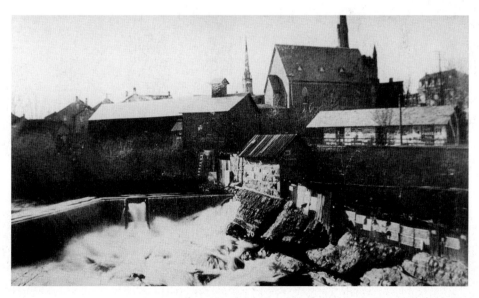

McMichaels Falls in Stroudsburg provided the waterpower needed to propel industry. Seen along the creek's banks are the old gristmill and various other industries.

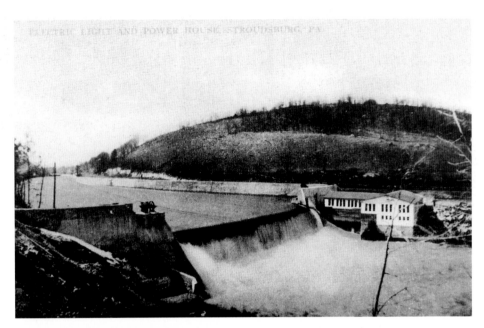

Until the Stroudsburg Electric Light and Power Company came along, a lamplighter was hired to ignite the oil or gas lamps at dusk, and the local policeman had to extinguish them (but not before 1 in the morning). In 1889, the electric company installed light poles and arc lights. Not until 1895, however, was the lamplighter discharged.

The Stroudsburg Woolen Mill, organized by Thomas Kitson, began operating in the winter of 1866. The mill manufactured wool fabric sold to the New York market. In 1898, employees won a world record for making a suit at the mill. In six hours and four minutes, they sheared sheep, prepared the wool, wove the fabric, and constructed the suit. The owner proudly sported the suit at a gala dinner that evening.

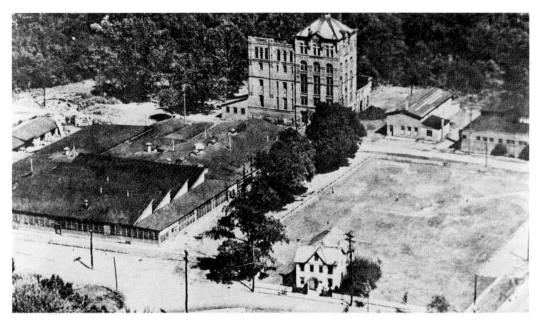

For those who jest about spouses' spending habits "putting them in the poorhouse," Stroudsburg did indeed have one. This image is of the Stroudsburg Brewery and Poorhouse. The poorhouse, seen in the lower right, stands in contrast to the brewery, the tall imposing building in the back, center of the photograph. Worthington Mower, now also gone from the area, was later located on the First Street, Stroudsburg property.

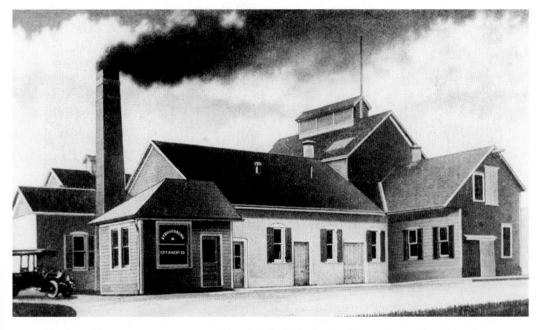

The Stroudsburg Creamery, as pictured in 1915, had Charles R. Turn as its president. The plant pasteurized and bottled milk and produced ice cream. Its butter was shipped as far as Washington, D.C. Local deliveries were made "by auto trucks and wagons," according to a 1915 advertisement.

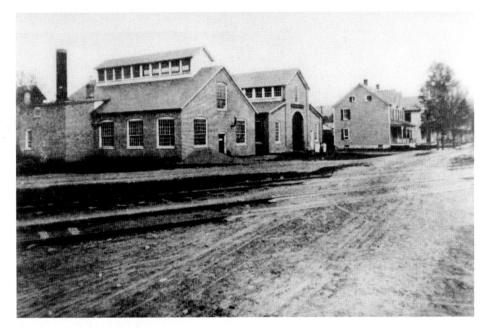

Stroudsburg Engine Works, built in 1903, manufactured steam-powered hoists and winches, which were important for the building of bridges. Production of their equipment proved vital during WW II for the loading and unloading of ships. In later years, the plant's mechanically powered winches were used to pull nets from shrimp boats, and they are still used all over the world, although the plant closed in 1989. The building now houses an antique market on Third Street in Stroudsburg.

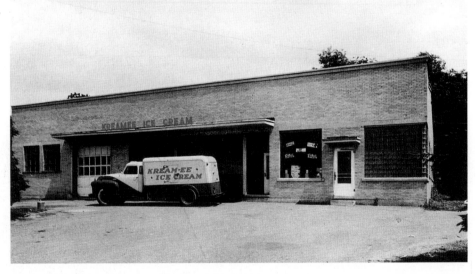

Many residents remember the dixie cups and popsicles produced by Kream-ee Ice Cream. Located near the J.M. School in East Stroudsburg, it was convenient to students, who would buy some tasty ice cream to top off their bag lunches. James Koppenhaver started the company in 1936 primarily as a commercial enterprise. One of Kream-ee's delivery trucks still stands within the now-vacant building.

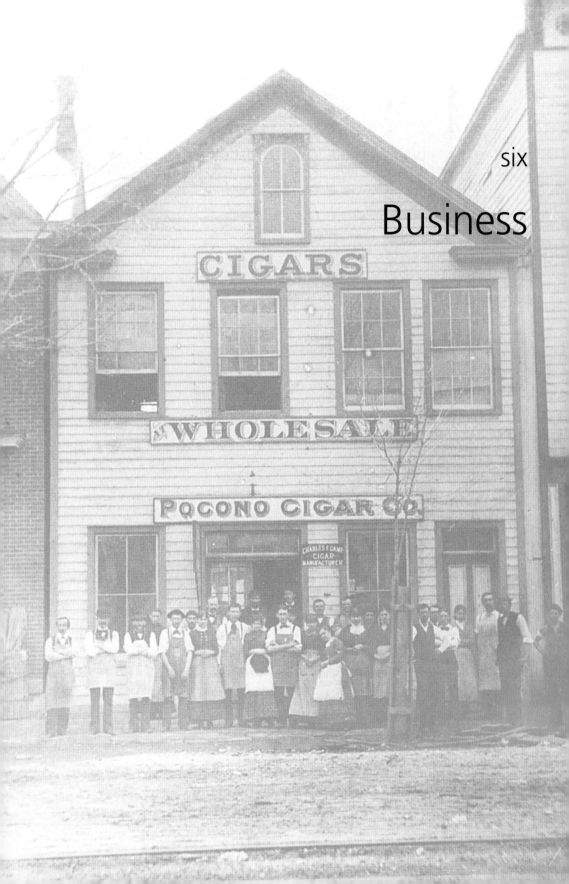

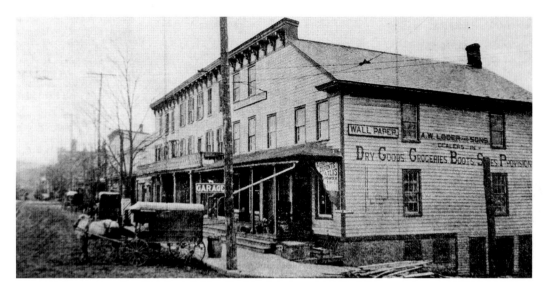

Alexander Loder's store, one of East Stroudsburg's earliest businesses, opened in 1868. It was known as A.W. Loder and Sons until after 1915, when a Loder operated a flower shop in the building. The florist's business stayed open until 1926.

As business goes, Jacob Stroud appears as the most astute early businessman. He operated a store in front of his residence at Fort Penn, selling wolf traps, goose necks, whiskey and gin, flour, shoes, leather, calico, and other necessities. Near his home he had a gristmill, sawmill, and blacksmith shop.

In the late 1800s, the Stroudsburg Board of Trade, forerunner of the Chamber of Commerce, worked to bring business to the area. East Stroudsburg developed a similar board.

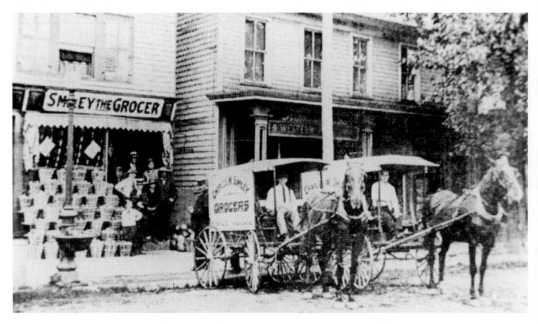

Another store, Charles Smiley's grocery store at 35 Crystal Street, East Stroudsburg, made two deliveries a day. The conductor and motorman on the trolley would often slip in for a snack while waiting for the trolley to pass at the switch in front of the store.

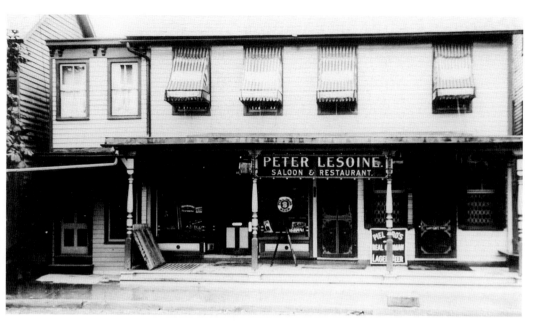

A few older residents remember Peter Lesoine's Saloon, situated across from the railroad depot in East Stroudsburg.

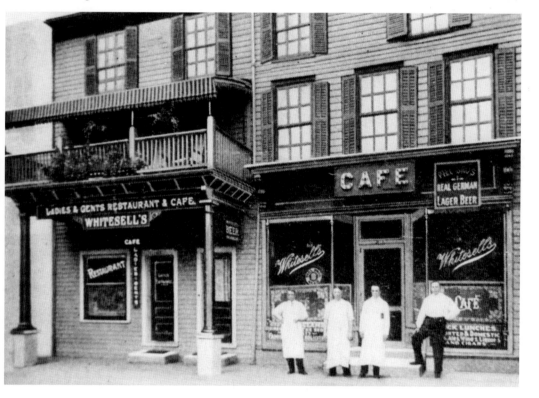

In 1911, Whitesell's Café on Crystal Street offered separate rooms for ladies and gentlemen. Seafood was the café's specialty.

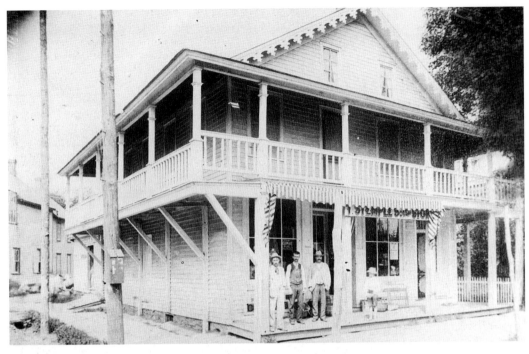

Stemple's Store, once across from East Stroudsburg National Bank (now PNC bank), passed out of existence before 1911. Owned by Thomas Stemple, it was built in 1863. A Gulf Station was later constructed on the land. (Courtesy of Charles Garris.)

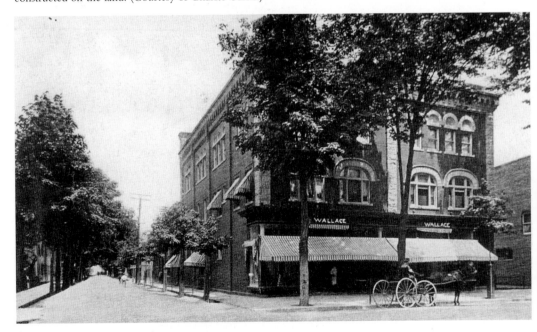

Wallace's Department Store opened in 1899 with Joseph Wallace and son Charles selling dry goods, clothing, and groceries. Today a card and gift shop occupies the building at Sixth and Main Streets in Stroudsburg.

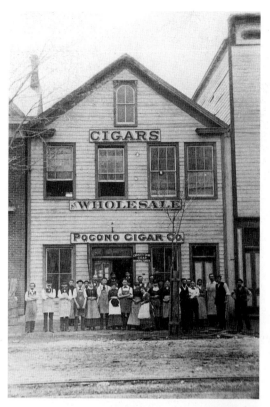

Left: Cigar making, once a common industry in the Stroudsburgs, called for locally grown tobacco. Pocono Cigar Company has passed out of remembrance. It was located on Main Street, Stroudsburg near today's Flowerland and Pocono Sew and Vac. (Courtesy of Charles Garris.)

Below: Cooke and Wyckoff began the New York Store in 1875 that, eventually named A.B. Wyckoff's, grew to become known as "the largest small-town department store in Pennsylvania." Five generations of Wyckoffs managed the store, which grew to employ over four hundred people at a time. (Sketch courtesy of Walter Wyckoff.)

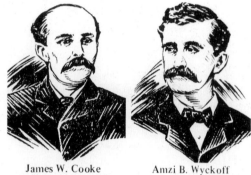

James W. Cooke Amzi B. Wyckoff

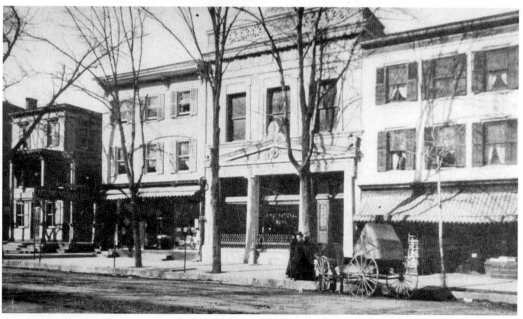

Pictured here are the First National Bank and the New York Store on Main Street in Stroudsburg. The New York Store, later called Wyckoff's, razed the 1882 bank for additional space.

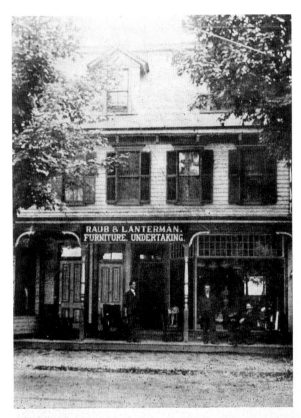

Left: Raub and Lanterman started an undertaking and furniture business in 1870. It has remained in the family since then, and is currently known as Lanterman and Allen Funeral Home.

Below: In 1915, Mrs. J.H. Lanterman opened her Piano and Talking Machine Store adjacent to the funeral parlor. Here she sold victrolas and records in addition to different models of pianos.

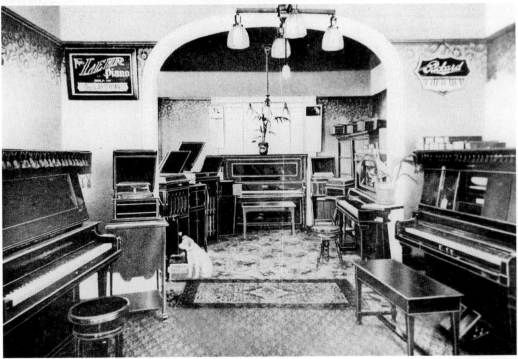

Right: Seen in 1915, the Daylight Store was given its name because its location and windows gave illumination even without the benefit of electric lights. When Dr. Joseph Henry, M.D. built the store in 1909, it was the largest commercial building in East Stroudsburg. The world-famous musician, Fred Waring, later purchased the building and used it as a center for Shawnee Press.

Below: In 1911, J.J. Newberry opened the first of his chain of "5 and 10 cent" stores in Stroudsburg. This view is of the original storefront. Several years later, the store relocated to the corner of Sixth and Main Streets, where, in later years, a newer building displayed a large sign proclaiming "Stroudsburg, Birthplace of the Nation-Wide J.J. Newberry Co. Stores."

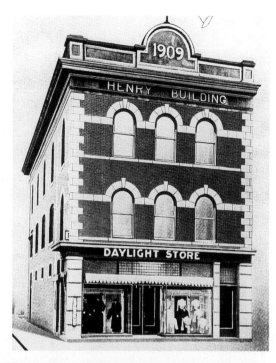

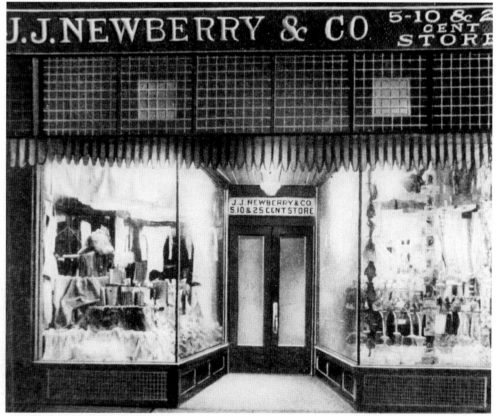

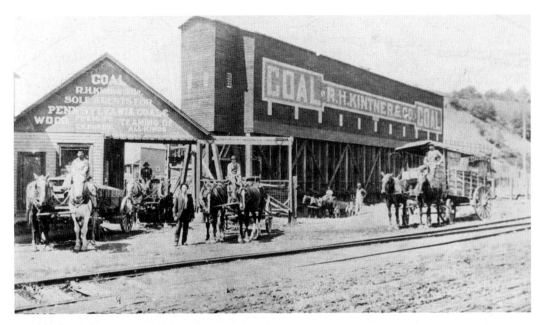

This old postcard shows R.H. Kintner's yard on Fourth and McConnell Streets. Remnants of the coal yard still exist, along with the old railroad overpass that made coal shipment handy to the business.

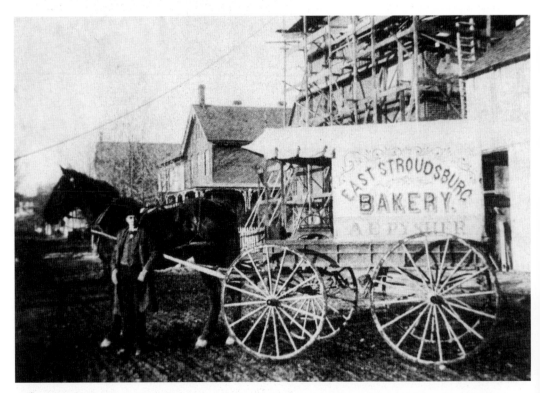

In 1901, Adam Pysher at 91 Crystal Street delivered his delicious baked goods. For small orders, people could walk in and savor the aroma while making their purchase.

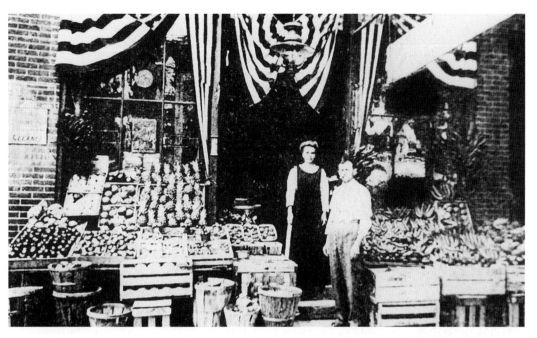

Seen in 1911, James and Cass Farry stand in front of their 603 Main Street Stroudsburg store. In addition to an array of fresh fruits and vegetables, Farry's Market offered as its specialty "fine cigars and tobacco," no doubt provided by the many cigar-producing industries in the Stroudsburgs.

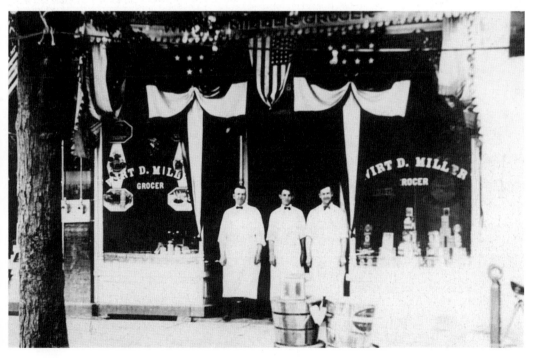

Wirt D. Miller and his son operated their specialty food store in the early 1900s. It was located several doors west of Kresge-LeBar's Drug Store. (Courtesy of MCHA.)

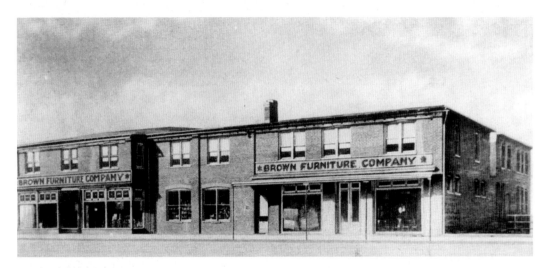

Secured as a new industry by the East Stroudsburg Board of Trade, Brown Furniture opened its business in 1910, selling Artcraft oak furniture. Many resorts numbered among its customers.

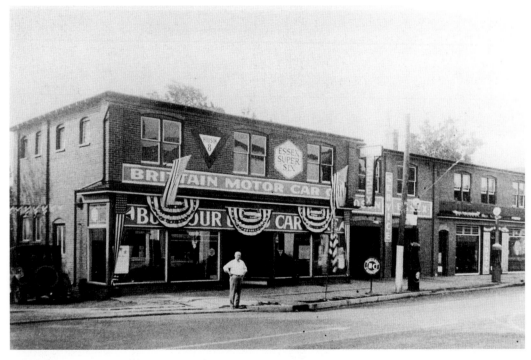

Brittain Motor Car Company later occupied the Brown Furniture building, selling its Hudson and Essex cars. Later, it served as a Packard dealership. Mesko Glass conducts business there now.

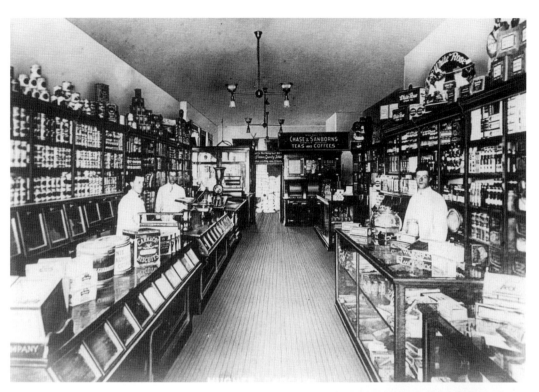

Above: In 1914, Hughes Grocery opened with William A. Hughes as proprietor and Edwin Hughes and James Bunnell as clerks. They made the usual deliveries of the time, first by horse and buggy and later by automobile.

Right: Shown is Theodore Schoch's Printing Office in later years. In 1841, Schoch bought the newspaper, the Jeffersonian Republican. In those days, newspapers operated as political organs, and the newspaper rivaled the Times Democrat.

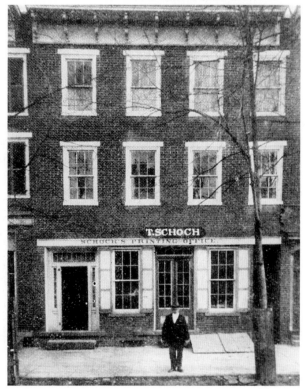

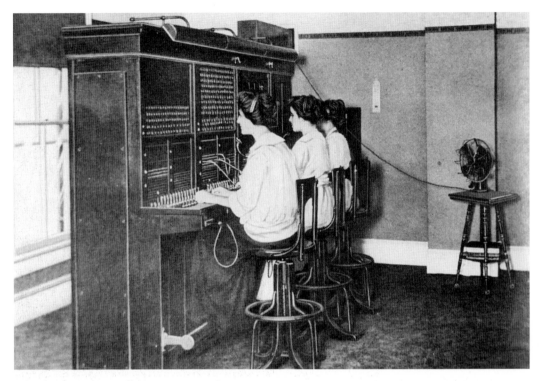

"Number, please?" In 1915, busy switchboard operators at the Stroudsburg and Bushkill Telephone Company offered the personal touch.

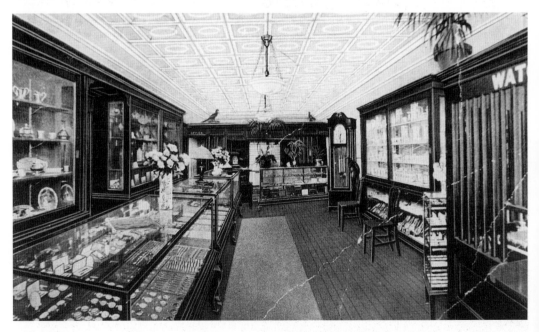

Burt Gaylord operated Gaylord's Jewelry Store on Main Street in Stroudsburg. Pictured is the interior in a time when "diamonds to please the most fastidious" could be purchased for under $10.

Right: The Kistler store opened in 1889, and remained in the family until 1960, when East Stroudsburg National Bank purchased it for additional parking.

Below: For an excellent 5¢-Rose-O-Cuba cigar, Gold Medal Flour, or soda fountain supplies, retailers and resort owners, ordered from L.D. Sopher. The company opened in 1910 at 40–42 North Courtland Street where Mack Printing now stands. The building burned in about 1916. Davies Strauss Stauffer built a similar wholesale house in its place.

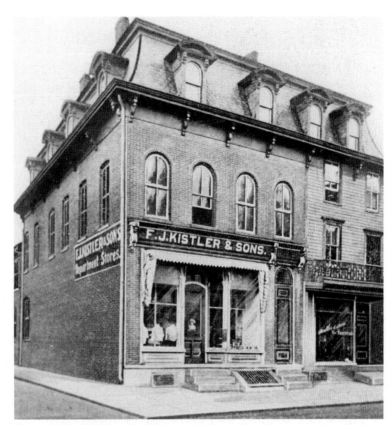

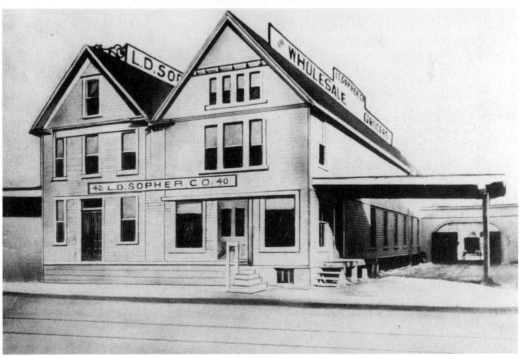

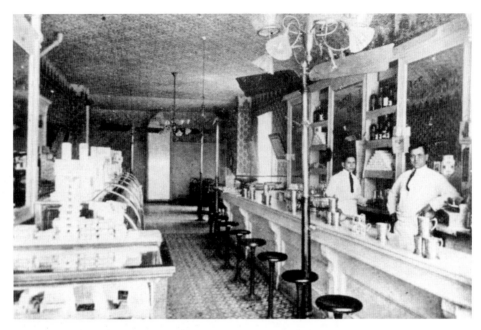

Pictured in 1915 is the East Stroudsburg Candy Kitchen, where Proprietor Andy Tsukatos featured fresh homemade chocolates and ice cream, sundaes and sodas. In 1927, Tsukatos moved his business down the street to what most residents remember as the Sweet Shop, later Summa's Barber Shop.

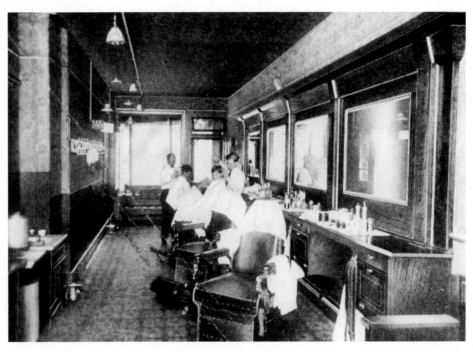

Shave and a haircut, two bits? In 1915, Watson's Barber Shop at 23 Crystal Street would trim or crop that beard. It was also a handy place to swap the news of the day.

Hotels and Inns

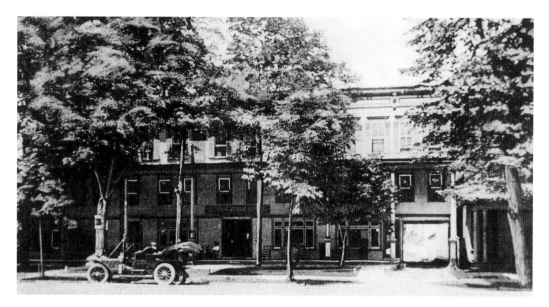

The Indian Queen Hotel, a popular stagecoach stop in the early 1820s, added a stage office in 1854. The first automobile to visit Stroudsburg stopped by the hotel in 1899. When the telephone company arrived, Indian Queen was among its first subscribers.

Initially, the stagecoach route helped Stroudsburg lead the towns in providing hotel accommodations. The later arrival of the railroad in East Stroudsburg produced hotels in the neighboring town, while also bringing more hotels and clientele to Stroudsburg.

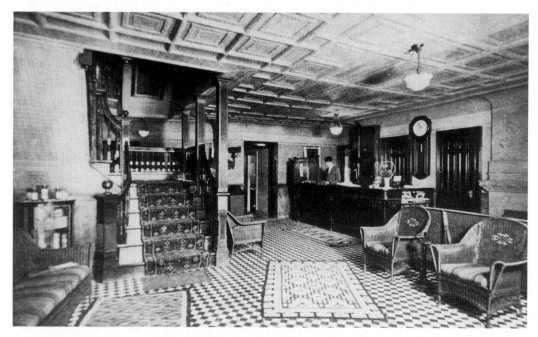

Many a visitor passed through the lobby and by the office of the Indian Queen. In later days, large groups of civic leaders attended affairs held in its commodious banquet rooms. Time ticked away until the hotel was torn down to make way for what is now the Mellon Bank on Main Street.

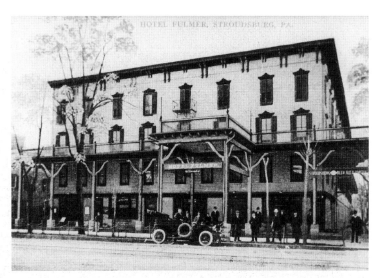

Stroud Jacob Hollinshead, grandson of Jacob Stroud, built the Stroudsburg House in 1833. The hotel underwent renovation in 1875 and reopened as the Burnett House, with running water and gas lights in every room. It was later renamed Hotel Fulmer and Penn Stroud.

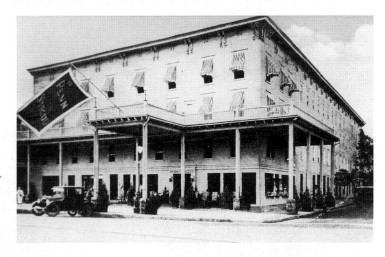

The Penn Stroud Hotel now operates as a Best Western. Its lobby still contains an old mural of Stroudsburg, but its appearance is somewhat different from when this photograph was taken.

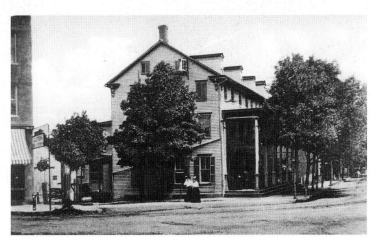

In 1828, Edward Posten built the Washington House as a stagecoach stop and interchange. The trolley later made it a convenient lodging for visitors. The venerable old hotel at Fifth and Main Street was razed after WW II.

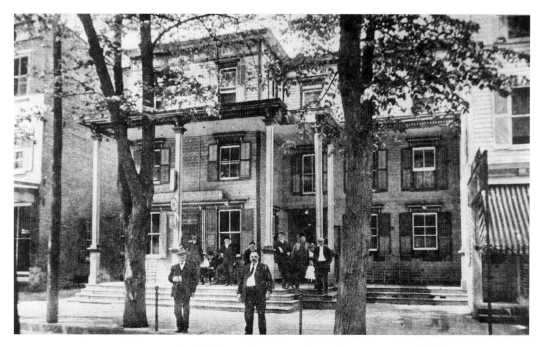

William Detrick, proprietor of the Central House is seen at the far right in this turn-of-the-century photograph. John H. Melick built the Central House, also known as the Fort Penn House, in 1851. The building was torn down to make room for Wyckoff's Department Store.

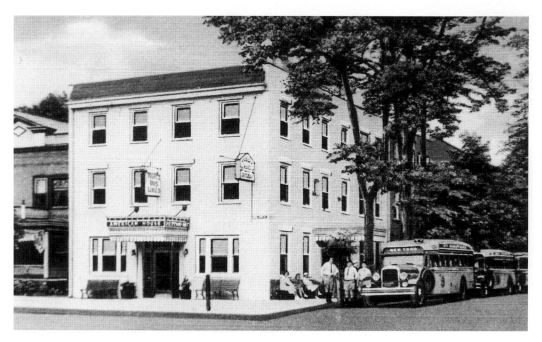

In later days, the American House, stripped of its ornate Victorian porch, served as a hotel and bus station.

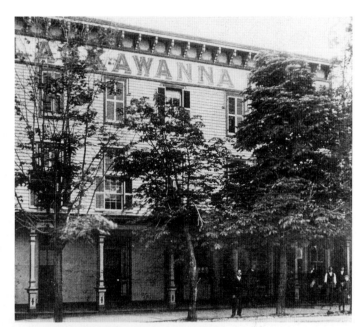

Right: This 1897 photograph is of the Lackawanna House, later known as the Lackawanna Hotel. Financed by Isaac T. Puterbaugh, it was built by Abraham Cott in 1874. It stands today as East Stroudsburg's oldest remaining hotel building.

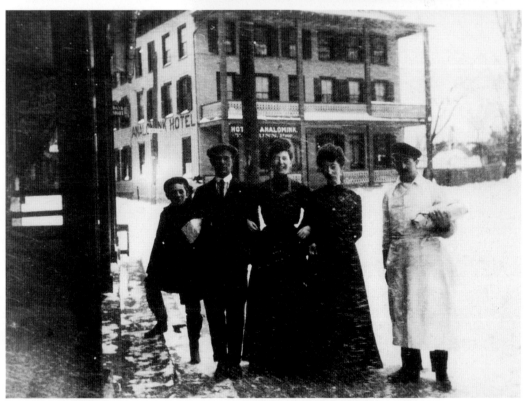

In the foreground of the Analomink Hotel, passersby pose with a butcher, who probably worked at Loder's nearby store. In 1870, East Stroudsburg's first council had their first meeting at the hotel, where they continued to convene for many years.

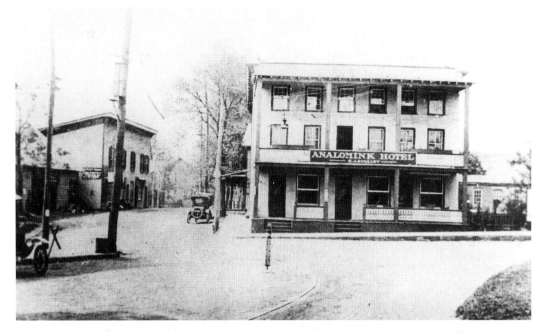

A later view of the Analomink Hotel reveals a somewhat run-down building. It was razed in 1935 for a newer post office, and the municipal building has occupied the site since May 23, 1970, the centennial of the borough's establishment.

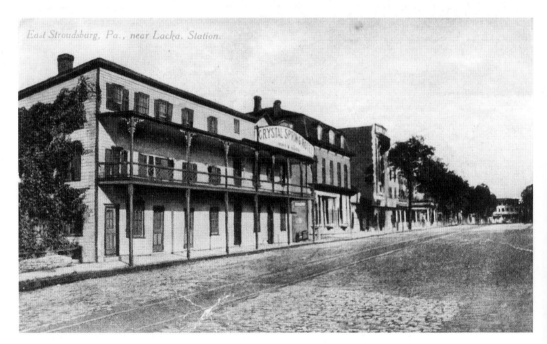

John Thomas, of Maine, built East Stroudsburg's first hotel, Crystal Springs, in 1856. It burned in a fire on February 1, 1910 and was later replaced by the Fenner Hotel. The Analomink House is seen at the end of the block on the far right.

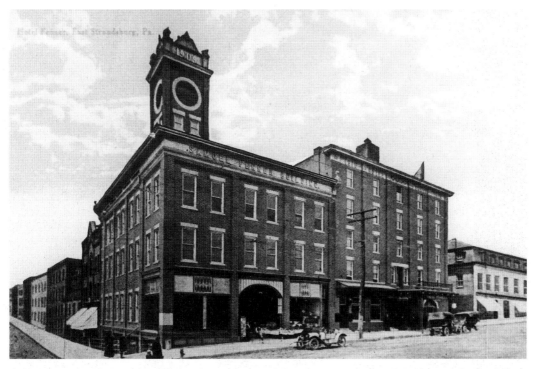

The Fenner building rose "like a phoenix from the ashes" of the Crystal Springs Hotel. Samuel Fenner built the second hotel in a complex later housing a blouse factory and various businesses. The Fenner Building was razed to make room for bank parking, and today its clock stands above the municipal building.

Mrs. Charles Dearr, proprietress of the Prospect House, distributed this advertising postcard in 1925. The hotel served as a hospital during the 1918 flu epidemic. East Stroudsburg Baptist Church's parking lot now takes the place of the former hotel.

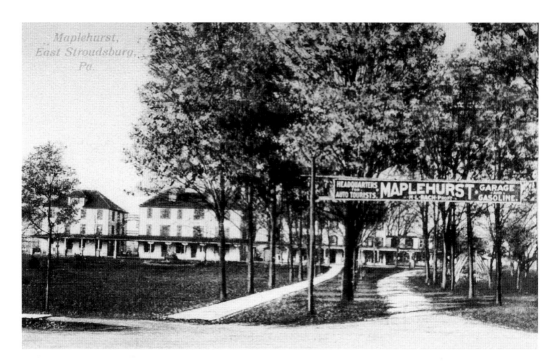

The Maplehurst, East Stroudsburg's first resort, was originally known as the Locust Grove House. William Findley Bush, its first owner, built it in 1875, and sold it several years later to Martin Bach, who enlarged it to accommodate two hundred guests. East Stroudsburg School District later purchased the resort for school expansion.

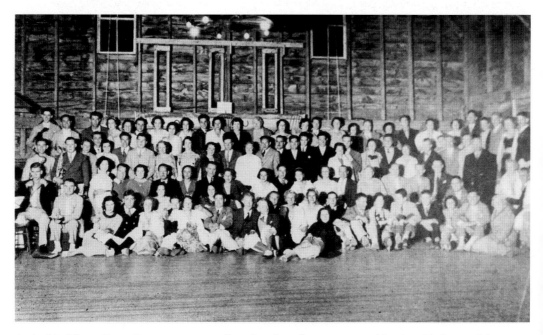

At the Maplehurst Dance Barn, many a tune floated to the rafters as guests and locals twirled around the dance floor.

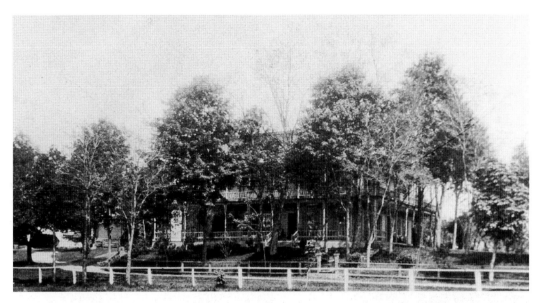

The Lawn Cottage was built before 1875 as Charles Durfee's residence and boardinghouse. Famous actor Joseph Jefferson, who was one of its first guests, gave it its name. The resort was the forerunner of Berwick Inn.

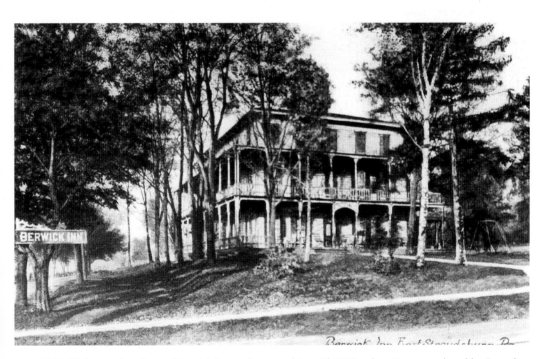

P.C. Dickerson bought the Berwick Inn and operated it until 1935, when it was purchased by Stroud Realty. The Berwick Heights residential development was built on the site of the old resort.

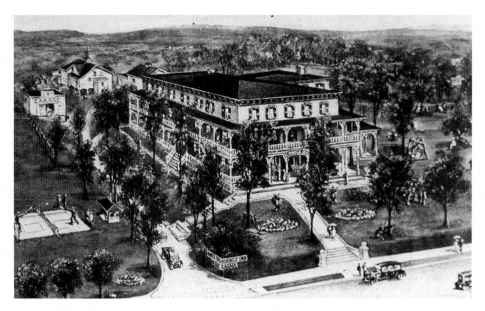

An aerial view of Berwick Inn gives us a glimpse of its tennis courts and outbuildings.

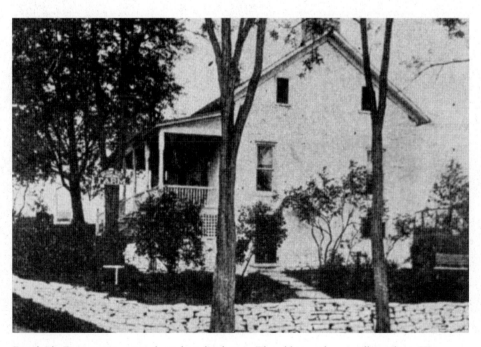

Brookside Farms once operated as a boardinghouse. The old stone house still stands on King Street in East Stroudsburg.

eight

In Times of
Crisis

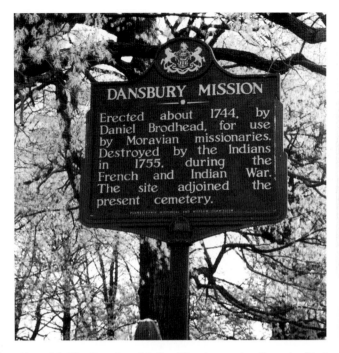

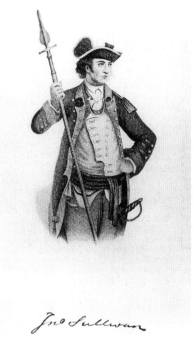

Above, left: The French and Indian War, known locally as the "Indian Wars," was among the first of the major crises that occurred in the Stroudsburgs area. At Dansbury Mission, it was reported that 11 members of the mission were massacred. The settlement of Dansbury was almost obliterated, with over 40 homes in the vicinity destroyed by fire.

Throughout this and other crises of fire and flood, the people were always there to assist others in time of need. Volunteers, officials, neighbors, and friends could always be counted upon to lend a helping hand or offer consolation.

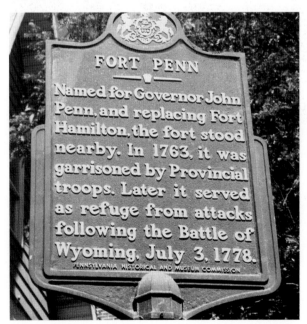

Above, right: The Wyoming Massacre in July 1778, created great carnage, and settlers from distant areas sought refuge in Jacob Stroud's Fort Penn. In early May of 1779, General John Sullivan, seen in the photograph to the left, came to Fort Penn to map out a strategy for the now-famous Sullivan's March to Wyoming.

Left: In 1776, Jacob Stroud built a stockade around his stone home and called it Fort Penn. A flood in the 1862 washed away the last remnants of the fort. The marker near the old Sherman Theater identifies its approximate site.

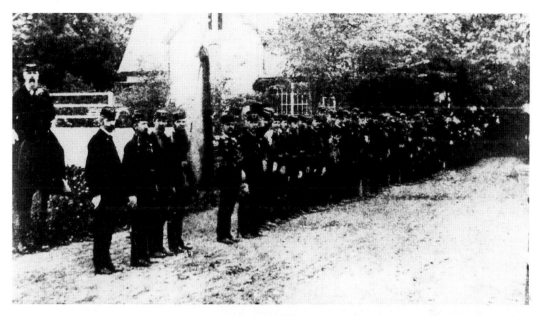

Pictured above is a group of local Civil War soldiers. Their local post, Wadsworth No. 150 GAR was organized on August 11, 1868.

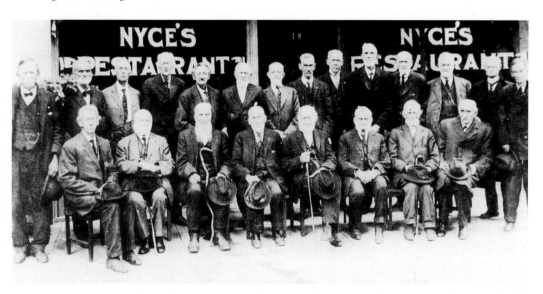

Pictured about 1905, Civil War veterans posed in front of Nyce's Restaurant in Stroudsburg. Some of the veterans pictured are: (front row) John McConnell (fifth from left); (back row) Abe Rhodes (eighth from right), Amos Schoonover (tenth from right), and Sid Walton (fourteenth from right). (Photograph courtesy of Beulah McConnell.)

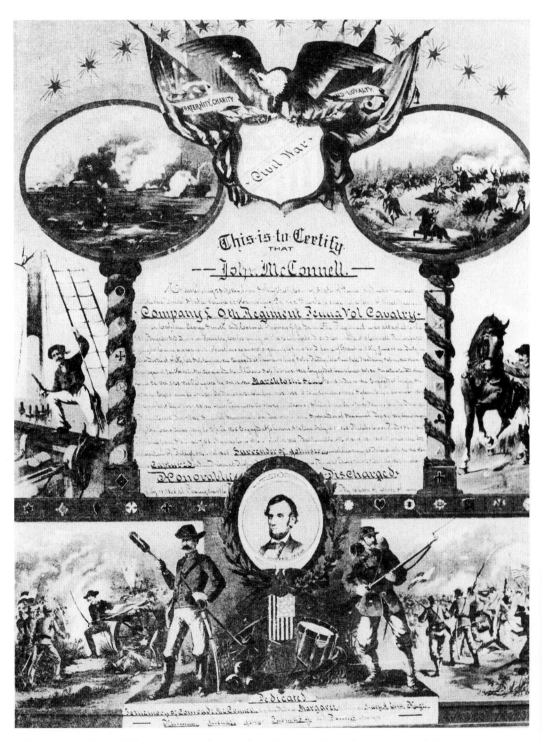

John McConnell, grandfather of James, John, Hugh, and Dan McConnell, was presented this ornate handwritten document decorated with pictures of Civil War battles. (Courtesy of Beulah McConnell.)

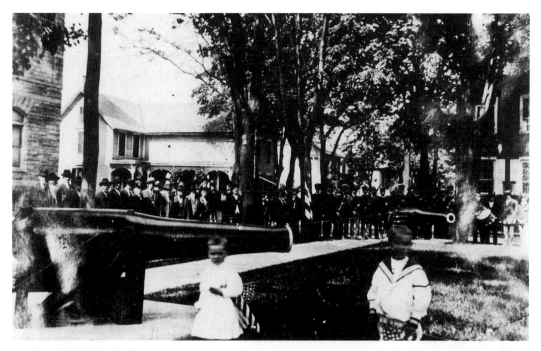

In a ceremony held about 1900, children reverently held their flags at the dedication of the cannons in Courthouse Square. In the background a line of adults stood solemnly by. (Courtesy of Beulah McConnell.)

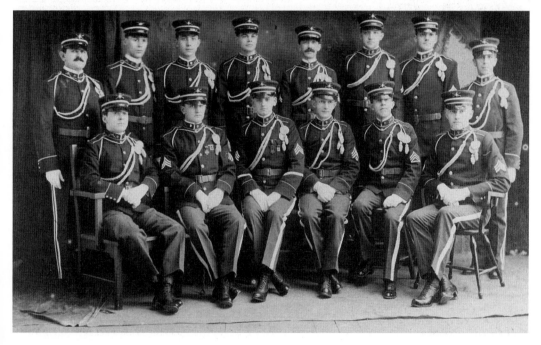

Fearing internal sabotage, the government first ordered Company G, 109th Infantry, 28th Division to the Easton/Phillipsburg area of Pennsylvania to guard the bridges. The soldiers later served at Camp Stewart, Texas. As the war escalated, the company faced enemy forces in France. (Courtesy of Beulah McConnell.)

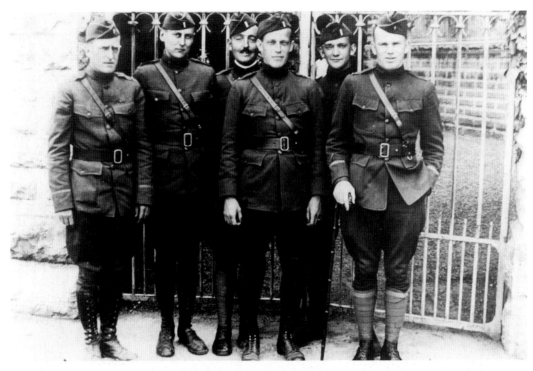

Lt. Giles Burlingame, first soldier on the left, is photographed when he attended the first caucus for the founding of the American Legion in Paris. (Courtesy of Gertrude Hershey.)

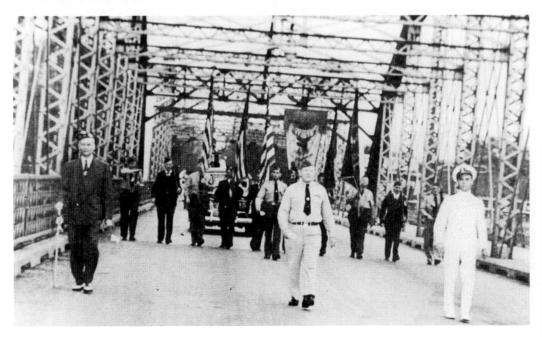

An Elks Flag Day Parade crosses the State Bridge between Stroudsburg and East Stroudsburg in 1944. Veterans of Foreign Wars lead the parade. The bridge was subsequently destroyed in the Flood of 1955.

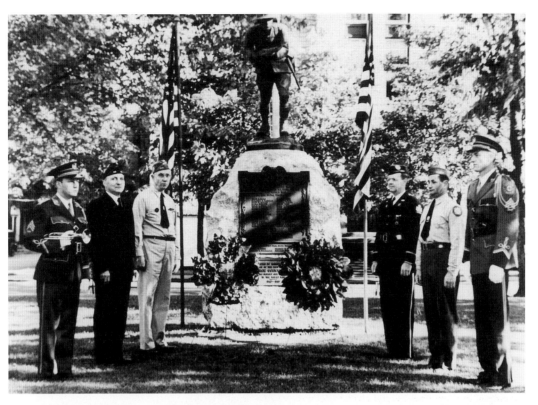

In the 1940s, members of the military conducted a commemoration service at the Doughboy Monument, erected in 1919 in Courthouse Square in tribute to WW I veterans. (Courtesy of Beulah McConnell.)

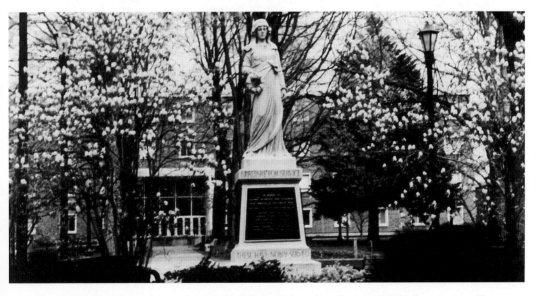

Amid the soft, delicate finery of spring, "Julia" stands in quiet tribute to WW I veterans mortally wounded in the springtime of their lives. Students of Latin studying Julius Caesar at the Normal School gave her the nickname. She is situated in the circle at East Stroudsburg University.

Just about every drafted WW II soldier passed by the desk of Beulah McConnell. Aware of her painful duty, this petite, soft-spoken woman greeted draftees with a smile and tried to soften matters with a joke. She served as an assistant and later executive secretary in the draft office, from 1940 until the Selective Service Office closed in 1974.

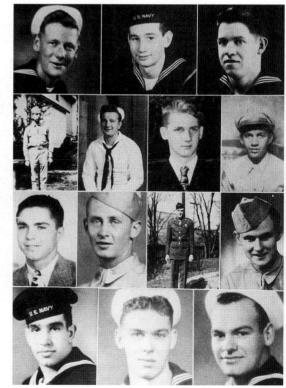

East Stroudsburg High School dedicated a 1945 yearbook page to its student soldiers, pictured in their uniforms. (Courtesy of ESHS.)

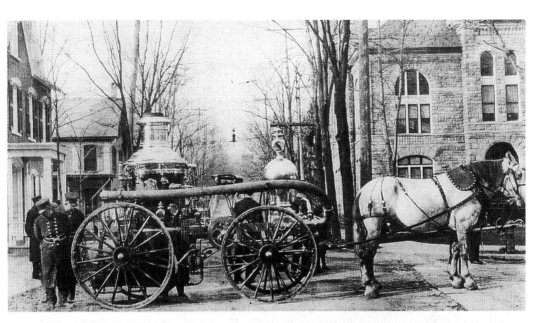

Firemen used "Der Mercheen," the 1871 steam fire engine of Stroudsburg's Phoenix Fire Company, to protect life and property in early days. Two fire companies constitute Stroudsburg's volunteer fire department: Phoenix, organized in 1866, and Chemical, established in 1910. (Courtesy of Stroudsburg Fire Department.)

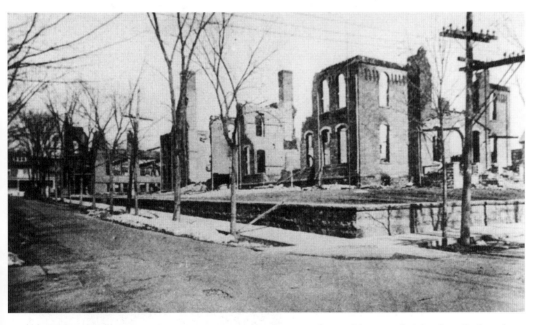

On February 26, 1927, a fire erupted in the central tower of Stroudsburg High School on Sixth and Thomas Streets, setting the school ablaze so quickly that firemen could not quell the flames.

East Stroudsburg offered use of its high school, and split sessions were held. East Stroudsburg conducted morning sessions, and Stroudsburg students had class in the afternoon. Classes were also held in the Methodist and Reformed churches.

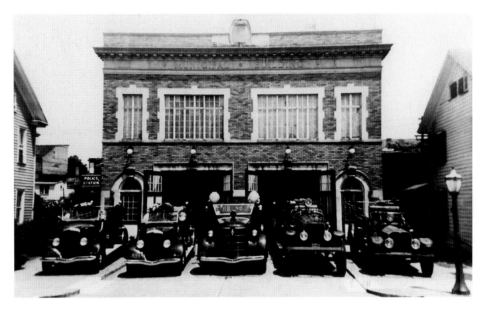

Engines line up in front of the firehouse on South Courtland Street. The East Stroudsburg Borough built the new firehouse for its volunteers, Acme Hose, in 1926. The building also housed the police department in the rear of the station and council chambers on the second floor. (Courtesy of Andy Secor.)

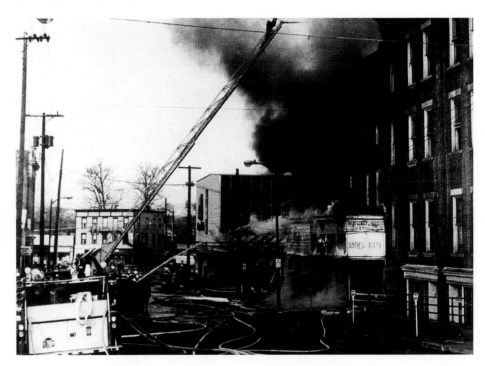

The fire companies of both towns cooperated in efforts to keep the blaze of the Silverman Store fire, on Washington Street in East Stroudsburg, from spreading further. (Courtesy of East Stroudsburg Fire Department.)

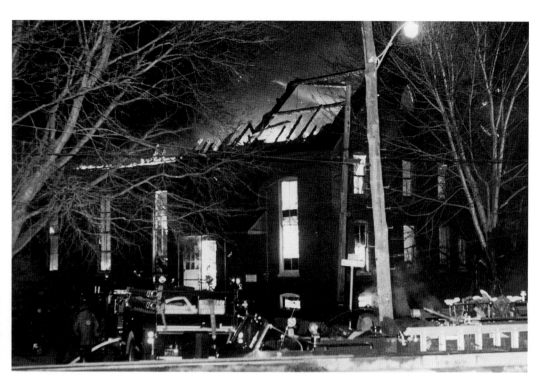

Above: When the old Presbyterian church on Analomink Street caught fire, firemen from all over the area helped to keep the entire street from catching fire. (Courtesy of Salvation Army Citadel, East Stroudsburg.)

Right: The Salvation Army always provides for assistance in emergencies. On Crystal Street in East Stroudsburg, Lucy Counterman Gueiss, one of those workers who provide food and drink to beleaguered firemen, dodges fire hoses on her mission. (Courtesy of Salvation Army Citadel, East Stroudsburg.)

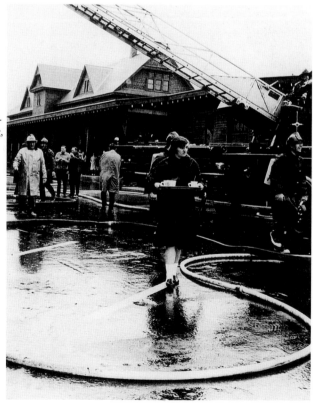

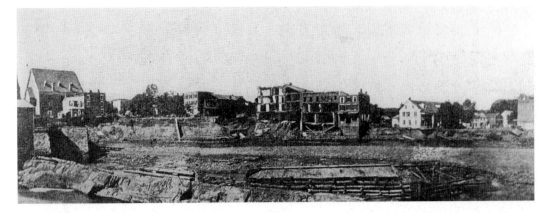

As the McMichael's Creek overflowed its banks, the 1869 flood inundated businesses lining Main Street in Stroudsburg. Workers shored up the banks of the creek with planking, and people said, "Never again!" However, the words of the sage, "Never say, 'Never' " held true. (MCHA photograph.)

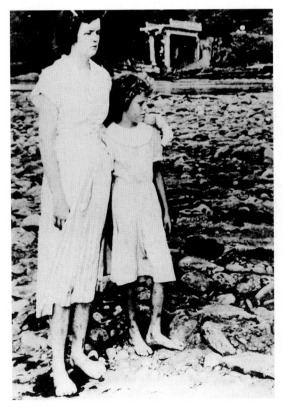

The flood of 1955 caused great loss of life and property. Clinging together amid the rubble of their world, stood two young girls at Camp Davis outside East Stroudsburg. Nancy Johnson, age 19 (left), and Linda Christensen (right) were two survivors of the Camp Davis tragedy that claimed almost 40 lives. For several hours Linda floated on debris until she was rescued. (Courtesy of Express-Times.)

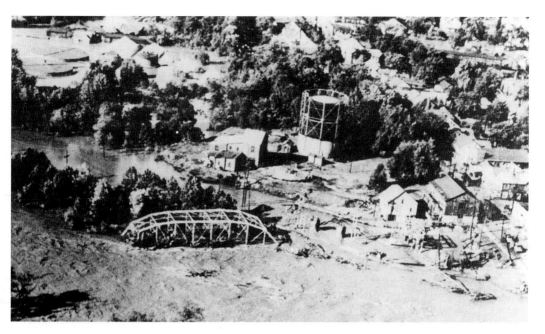

The floodwaters destroyed the Interborough Bridge, carrying it downstream and isolating the towns. It was one of about 20 bridges washed away by the storm. The plaque on the old state bridge now resides in the Monroe County Historical Society building. (Courtesy of Express-Times.)

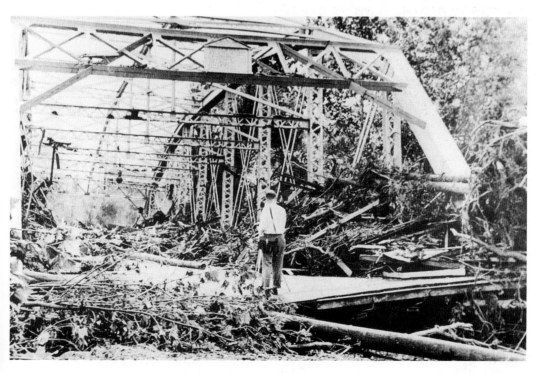

An official inspects the debris-clogged bridge after the floodwater receded, no doubt shaking his head over how the normally tranquil stream could have wreaked such havoc. (Courtesy of Express-Times.)

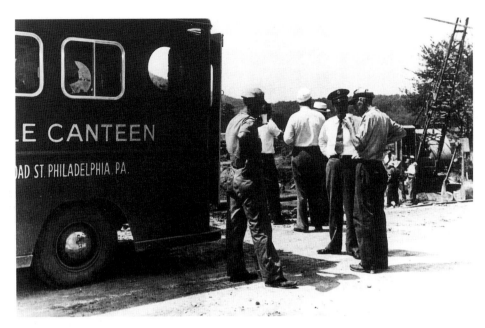

Support teams from many distant towns came to help. Here, officials discuss emergency flood plans. (Courtesy of Salvation Army Citadel.)

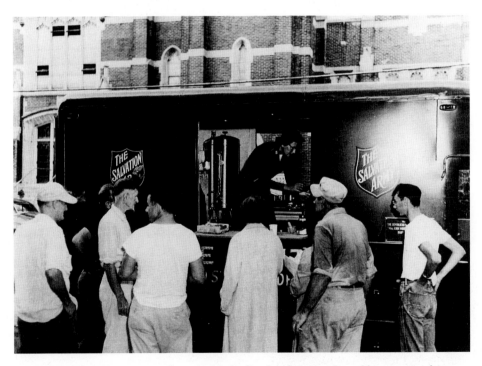

A Salvation Army canteen across from the Methodist church in East Stroudsburg constantly provided sustenance to flood victims. It numbered among the many thousands of organizations and people who provided financial, physical, emotional, and spiritual support in one of the worst disasters to strike the northeastern United States. (Courtesy of Salvation Army Citadel.)

nine

Notables

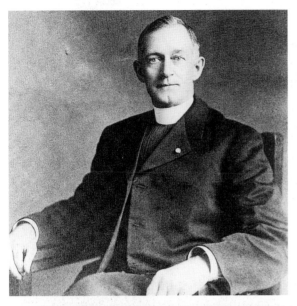

Reverend Francis M. Craft served as the first pastor of St. Matthew's Church in East Stroudsburg from July 4, 1902 until his death in 1920.

Viewing the simple portrait of a parish priest, one might think he'd always experienced a cloistered life, yet few have led a more exciting, complex existence. Born in 1852, he moved with his family to Pike County, Pennsylvania. When he was ten, his father gave written permission for him to join the Union Army in Gettysburg. Although unsuccessful in enlisting, he reportedly got into the middle of battle, suffering wounds. That marked the beginning of his military career. In 1870, he was a sharpshooter in the Franco-Prussian War, he led a band of mercenaries in Cuba in 1871, and he served in the Spanish American War as well.

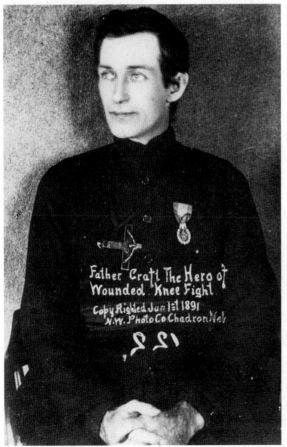

Father Craft The Hero of Wounded Knee Fight
Copy Righted Jun 1st 1891
N.W. Photo Co Chadron Neb.
122

Attempting to insure that no injustice occurred against the Sioux, Father Craft accompanied Forsyth's command in 1890 to Wounded Knee in South Dakota. The priest's medical degree, obtained from Louvain University in Belgium, further qualified him for the expedition. Although a severe knife wound pierced his right lung during the battle, he tended wounded soldiers until he collapsed.

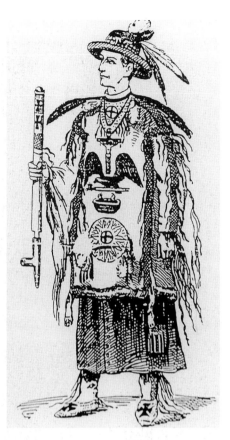

Right: The Dakota Native Americans honored Father Craft for his work with Native Americans by making him a chief. Known as "Hovering Eagle," he appears in full regalia in this sketch published in the Irish World on August 16, 1890.

Below: During Father Craft's 15 years of ministering to the Sioux Native Americans, he established the Congregation of American Sisters, an order of Native American nuns whom he trained as nurses. Here he is pictured with some of them at Camp Onward in Savannah, Georgia, while accompanying them to Cuba for war service in 1898.

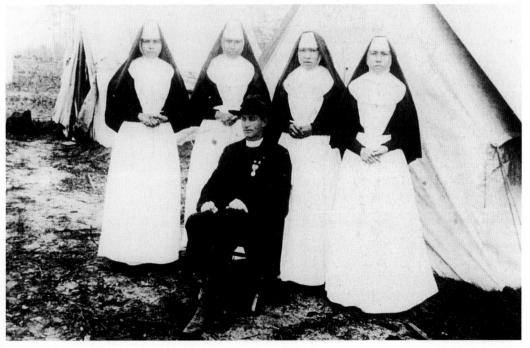

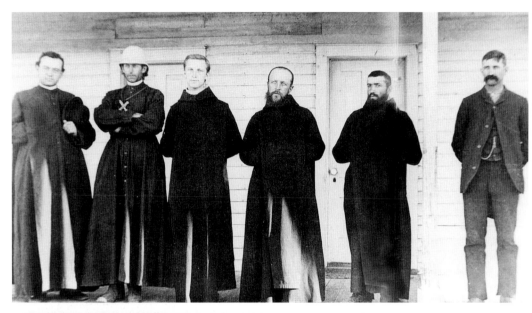

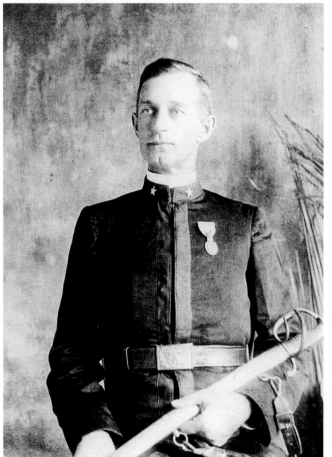

Above: Seen in pith helmet, second from right, Father Craft posed with Benedictines at the agricultural School of St. Benedict's Mission in South Dakota. William Whitsell, district farmer, is seen on the far left. This photograph was taken between 1886 and 1888.

Left: This photograph of Father Craft in his uniform was probably taken after the Franco-Prussian War, most likely while he was in Cuba, according to his biographer, Thomas W. Foley, of Dunwoody, Georgia.

Opposite: John Summerfield Staples's enlistment document as Abraham Lincoln's representative has the word "Substitute" crossed out and "Representative Recruit" written in its place. Since Abraham Lincoln as President was exempt from duty, John Staples made the symbolic gesture to set an example.

Representative Recruit

SUBSTITUTE
VOLUNTEER ENLISTMENT.

District
STATE OF [illustration] 3 and 8 **TOWN OF**

Columbia Washington DC

I, John S Steptle _____ born in the State
of Penn _____ aged thirty _____ years, and by
occupation a Labor _____ Do HEREBY ACKNOWLEDGE to have agreed with
Abraham Lincol _____ Esq. of 3 ward of District
the Representatin

to become his **SUBSTITUTE** in the Military Service, for a sufficient consideration paid and
delivered to me, on the first _____ day of October _____, 186 Y
and having thus agreed with said Abraham Lincol _____ I DO HEREBY
ACKNOWLEDGE to have enlisted this first _____ day of October
186 Y, HERE as a **Soldier** in the Army of the United States of America, for the period
of Three YEARS, unless sooner discharged by proper authority: I do also agree to accept such
bounty, pay, rations, and clothing, as are, or may be, established by law for soldiers. And I do
solemnly swear that I will bear true and faithful allegiance to the United States of America;
that I will serve them honestly and faithfully against all their enemies or opposers whomsoever;
and that I will observe and obey the orders of the President of the United States, and the orders
of the Officers appointed over me, according to the Rules and Articles of War.

Sworn and subscribed to, at Washington DC
this 1 day of Octe 186 Y John S Steptle
Before:
Capt Riley U.R.C
Provost Marshal
DC

We certify, on honor, That we have carefully examined the above-named Representative
agreeably to the Regulations, and that, in our opinion, he is free from all bodily defects and mental infirmity,
which would in any way disqualify him from performing the duties of a soldier; that he was entirely sober
when enlisted; that he is of lawful age, (not under 18 years;) and that, in accepting him as duly qualified to
perform the duties of an able-bodied soldier, and as a Substitute in lieu of Abraham Lincol
_____ who is not liable to draft
_____ 186 we have strictly observed the Regulations which govern
in such cases. This soldier has blue eyes, hair, dark complexion; is 5 feet 7
inches high.

J.P. Robinson
Capt 1 N.R.C Provost Marshal

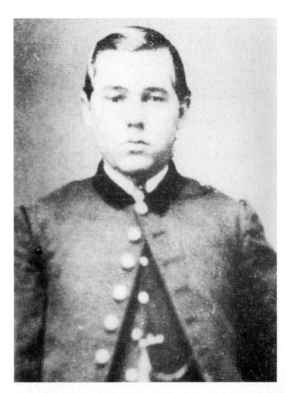

In 1864, President Abraham Lincoln advertised for a representative recruit, and a Stroudsburg native, 20-year-old John Summerfield Staples was chosen. At the time, Staples was in Washington with his father, a Methodist minister who served as chaplain in the army.

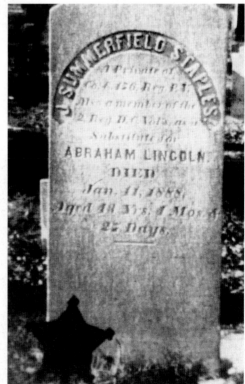

As seen on Staples's gravestone in Stroudsburg Cemetery, he died at the early age of 48. Sometimes referred to as Abraham Lincoln's "substitute," as carved on the marker, the term "representative recruit" is more accurate.

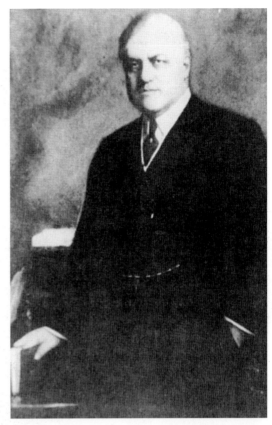

Right: Stroudsburg resident A. Mitchell Palmer is pictured as he ran for President of the United States. He lost the primary election. He served as a United States Congressman and also United States Attorney General under President Woodrow Wilson. With communists active in the country, Palmer's reactions led to opponents denouncing his political policies as the "Red Scare and Palmer's Raids."

Below: Situated at 712 Thomas Street in Stroudsburg, A. Mitchell Palmer's house is seen on the left of this postcard picture.

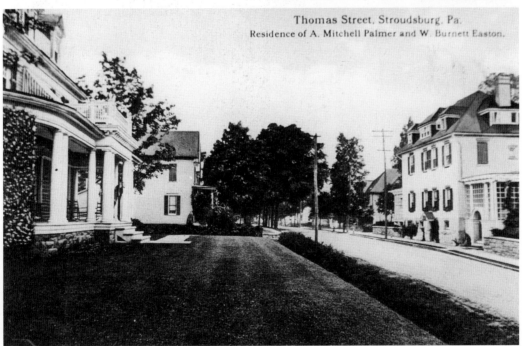

Thomas Street, Stroudsburg, Pa.
Residence of A. Mitchell Palmer and W. Burnett Easton.

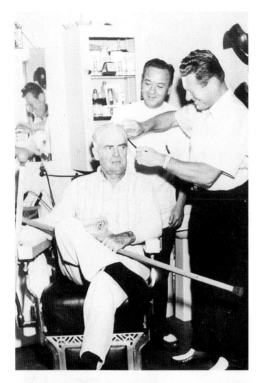

Left: The trio "ham it up" as Howard Everitt pretends to cut Fred Waring's hair and Don Summa observes.

Below: Famed musician Fred Waring supervised as barber Don Summa cut Malcolm Waring's hair. In addition to his other enterprises, Waring owned Shawnee Press at One Washington Street in East Stroudsburg. He was also renowned as the inventor of the Waring Blendor.

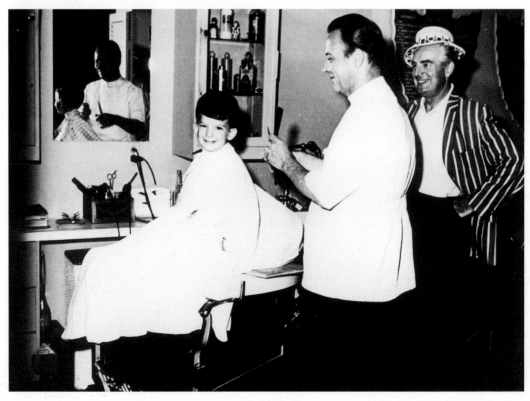

ten

Medicine

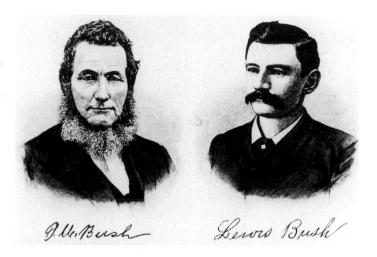

P. W. Bush *Lewis Bush*

Above: The "Bush Brothers," Doctors Horace and Lewis Bush, were among the first to graduate from an accredited school of medicine, Jefferson Medical College in Philadelphia. They both practiced in East Stroudsburg, where Horace became one of the first to establish a drugstore.

In early times, medical practitioners worked in crude conditions, with few facilities on hand. Apprentices often served as physicians until 1877 legislature required doctors to be licensed graduates of medical schools. Until drugstores opened, doctors had to prepare their own powders and nostrums or travel to Easton for supplies.

Below: Dr. Horace Bush opened his Crystal Pharmacy on 88 Washington Street, East Stroudsburg, adjoining his medical office. He had earlier sold a drugstore on Crystal Street to Rhodes and Dunning, who renamed it the Red Cross Pharmacy. Counterman's Drug Store later took over the Crystal Street building.

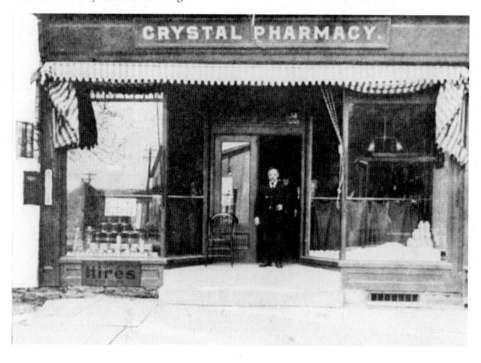

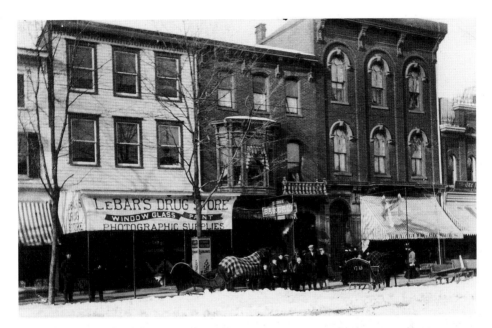

In 1880, Dr. Amzi LeBar bought the old Hollinshead Drug Store and renamed it LeBar's Drug Store. Store records show that as early as 1848, horseback carriers traveled for medicine from distances such as Newton, New Jersey. (Courtesy of Kresge-LeBar Drug Store.)

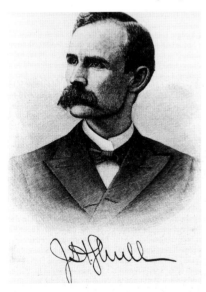

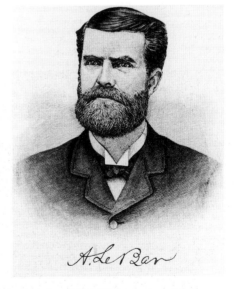

Above, left: Doctor and lawyer, Dr. Joseph Shull "wore two hats." In 1873 he graduated from New York University and two years later opened his medical practice in Stroudsburg. He "read law" (rules were not as stringent then), passed the bar exam, and practiced both professions.

Above, right: Amzi LeBar graduated from Jefferson Medical College in Philadelphia and opened his medical practice in Stroudsburg in 1873. Quick to adapt to newfangled devices, Dr. LeBar in 1889 obtained permission from Stroudsburg Borough Council to put up a wire and connect his two drugstores by telephone.

Monroe County General opened in 1906 as the county's first hospital. Tired of going to Scranton for hospital care, a prosperous individual bought a house at 519 Sarah Street in Stroudsburg and donated it to the Monroe County Medical Society. The society managed it until a merger was formed with East Stroudsburg's hospital.

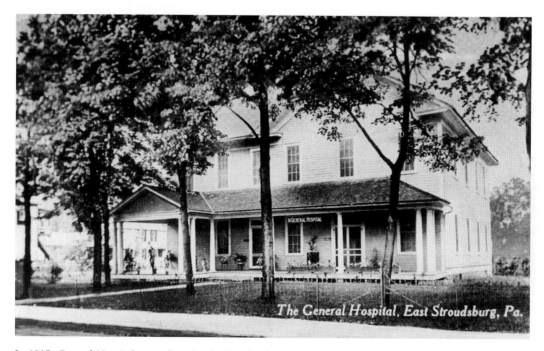

The General Hospital, East Stroudsburg, Pa.

In 1915, General Hospital opened on South Courtland Street, East Stroudsburg in a house where the Methodist church now stands. Ten doctors and three nurses staffed the 20-bed hospital. Surgeons from Scranton and Easton traveled by railroad to serve the hospital.

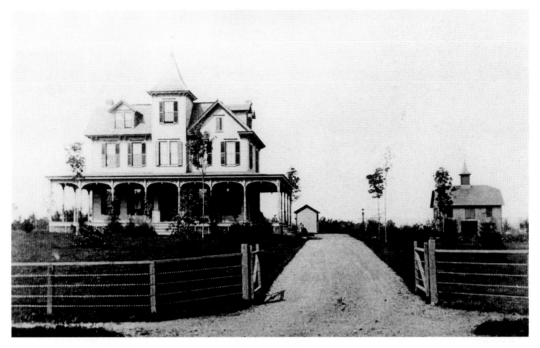

J.C. Roop, a retired chemist, owned this home on East Brown Street, East Stroudsburg. Lawn fetes were held here as fund-raisers for the General Hospital down on North Courtland Street.

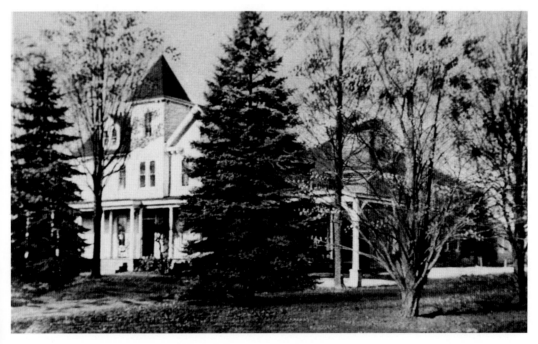

General Hospital purchased the J.C. Roop Estate in 1921 at the same location where earlier fund-raisers had been held. Hospital officials added a two-story wing to the mansion. Fruit trees, vegetable gardens, and barns housing chickens provided food for patients and staff.

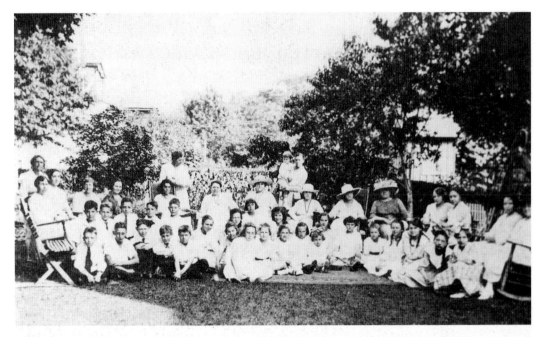

In 1920, hospital volunteers gathered on Mrs. Sally Booth's lawn. Mrs. Booth helped found the Ladies Auxiliary of General Hospital in 1915.

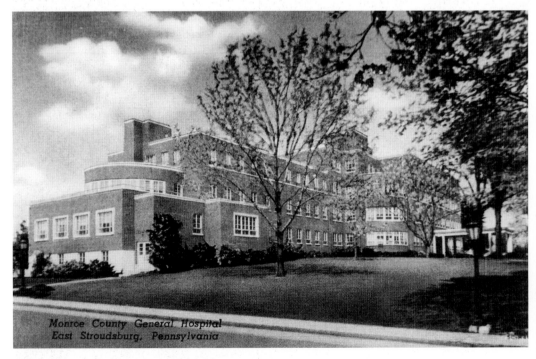

A December 1, 1930 merger combined Stroudsburg's Monroe County General and East Stroudsburg's General Hospitals, producing the General Hospital of Monroe County. In 1981, it was renamed Pocono Hospital, and today it serves as Pocono Medical Center.

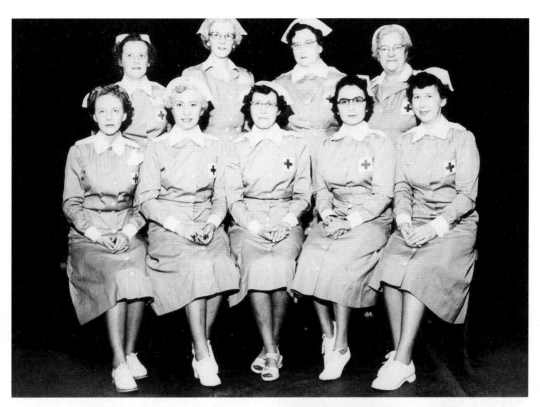

Above: Red Cross Gray Ladies organized to assist in patient care and welfare. Some of its first members are pictured above from left to right as follows: (seated) Mrs. Walter Dreher, Mrs. Sumar Schwartz, Mrs. Charles Cincotta Jr., Mrs. Charles Dean, and Mrs. Charles Mott; (standing) Mrs. Frank Reusswig, Miss Nora Lefler, Mrs. James Coleman, and Mrs. George Hauser. (Courtesy of Pocono Medical Center.)

Right: An unidentified nurse stood on the porch of East Stroudsburg Hospital in 1920. In addition to her regular duties, she would stoke the furnace on days when the janitor didn't show up. On "cook's day off," the head nurse cooked and served the meals. (Courtesy of Pocono Medical Center.)

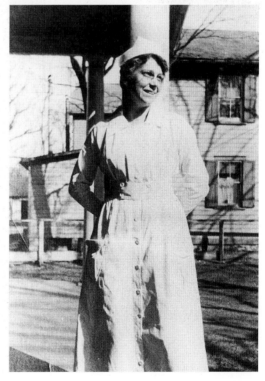

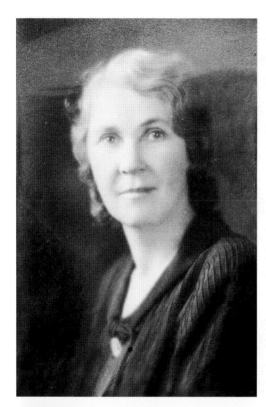

Left: A rare and unusual picture shows a hatless Dr. Nina Mae Price. Celebrated for her trademark hats, Dr. Nina avoided harsh light because of a snakebite during childhood affecting her eyes. She conducted her medical practice in the Stroudsburgs for over 50 years. (Courtesy of Robin Wheeler.)

Below: Dr. Nina, wearing one of her trademark hats is seen tending to a reluctant young patient. Daughter Shirley Wheeler wrote her fascinating biography, Dr. Nina and the Panther. (Courtesy of Robin Wheeler.)

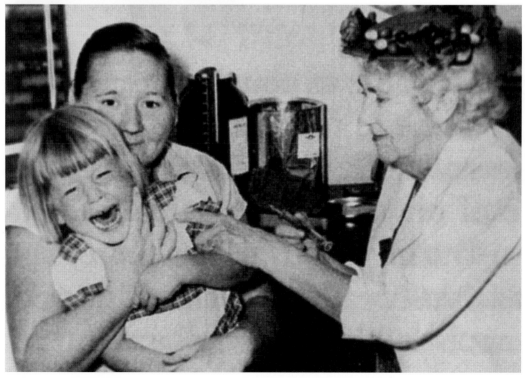

Right: Dr. Carl B. Rosencrans was the son of Seely Rosencrans, a co-founder of East Stroudsburg University. Dr. Carl opened the first surgical hospital to be owned by a private individual in East Stroudsburg.

Below; The Stroudsburgs' third hospital opened in East Stroudsburg in 1924. Dr. Carl B. Rosencrans started his private hospital at 171 Washington Street and operated it until his death in 1943. Dr. Searles Lanyon bought the hospital and he and his brother, Dr. Lyle Lanyon, maintained it until 1947.

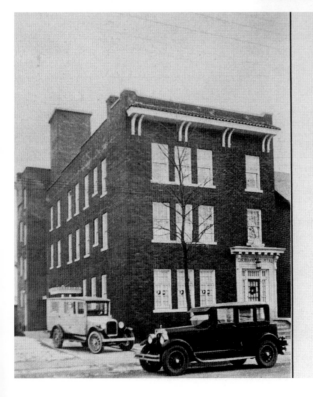

ROSENKRAN'S HOSPITAL

East Stroudsburg, Pa.

Best Equipped
Hospital In the East

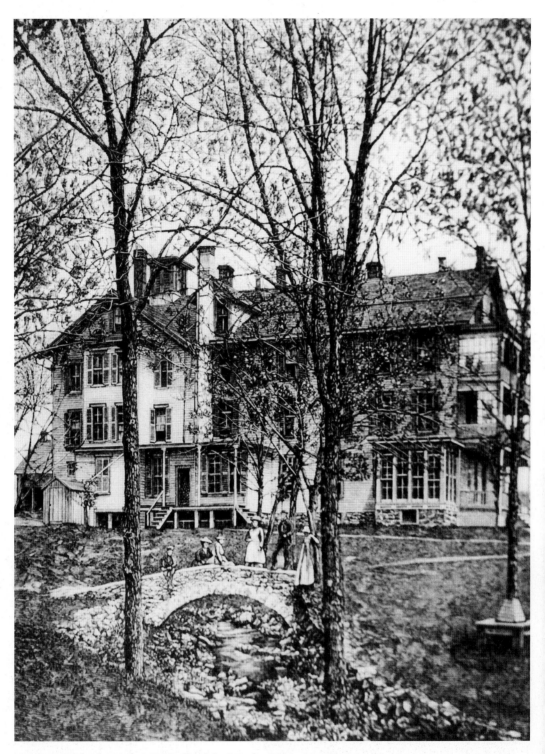

Hurd Sanitarium, founded in 1877, offered the "Wesley Water Cure," stressing a regimen of spring water and healthy foods. Located near the present Shannon Inn in East Stroudsburg, it burned in 1911 and was never rebuilt.

eleven

In School Days

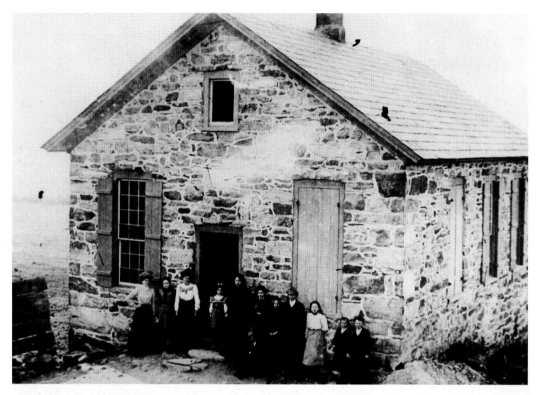

Pictured above, the Eilenberger (Hollow) one-room schoolhouse still stands in Shawnee, an area that is today part of the East Stroudsburg School District.

A prior school, the "Old Stone Seminary," located north of Eighth Street in Stroudsburg, was one of the earliest sites of formal education, starting classes in October 1838. Students from as far away as Luzerne and Pike Counties attended classes there.

School attendance was not required by law until 1897, when attendance became mandatory for children between ages eight and 13.

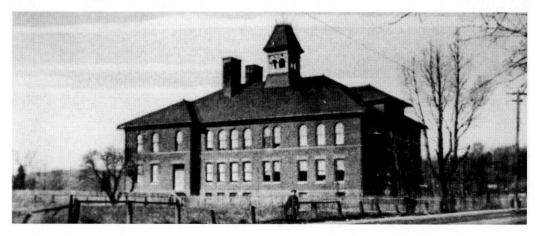

East Stroudsburg built this school for its students in 1894. It still stands today, called the "Bunnell" building. An adjoining school, constructed in 1916, was torn down upon completion of the new high school in 1960.

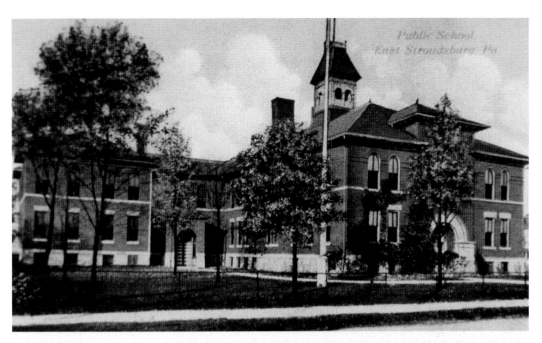

An annex later provided more space for the old high school, adding a gymnasium and additional classrooms.

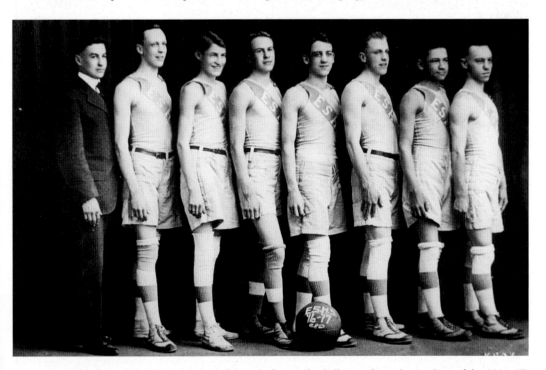

East Stroudsburg offered boys' basketball long before its football team formed. Members of the 1916–17 team, from left to right, are as follows: Clair Reynolds, Paul Burt, Luther Beers, Joe Greiner, Ed Hughes, Wilmer Lanterman, George Walton, and Andrew Pipher. (Courtesy of East Stroudsburg Area School District.)

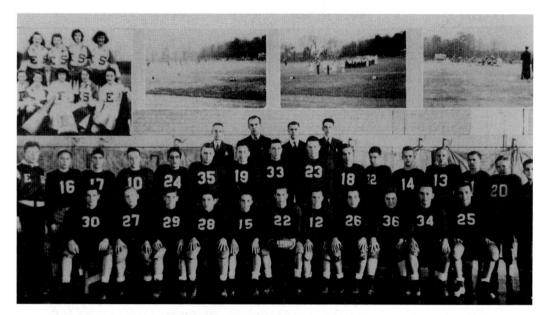

East Stroudsburg's first football team, pictured above, formed in 1944 with Lewis Hastie as their coach. The boys practiced without equipment, and their first games were played on East Stroudsburg State Teacher's College's field. (Courtesy of East Stroudsburg Area School District.)

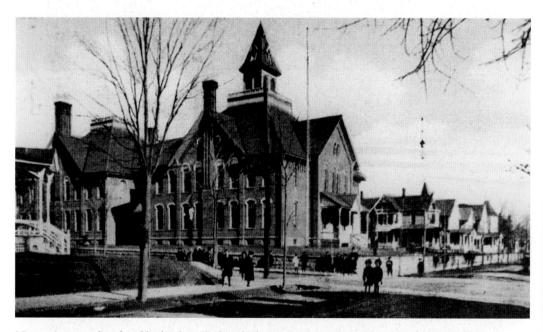

Not many remember the old school on Sixth and Thomas Streets in Stroudsburg. It served as both grammar and high school until 1927, when fire destroyed it. Ramsey Elementary School now stands in its place.

Opposite, above: Graduates of the Stroudsburg High School Class of 1896, had their commencement exercises at the courthouse that year, with graduation held on Saturday, June 6.

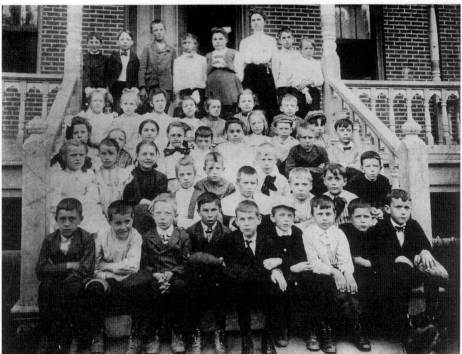

At the turn of the century, Miss Ella Phillips posed with her class on the porch of the old grammar school on Thomas Street. Two of her illustrious students were Marshall Metzgar, who later became a doctor (first row, third student), and James McConnell, who later became Stroudsburg's chief of police (fifth row, third student). (Courtesy of Beulah McConnell.)

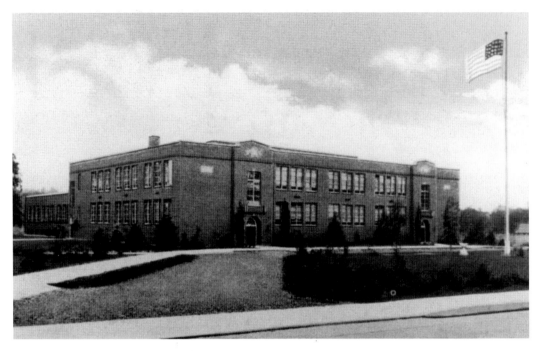

After a fire completely destroyed the high school on Thomas Street in Stroudsburg, the district completed this new high school in 1929.

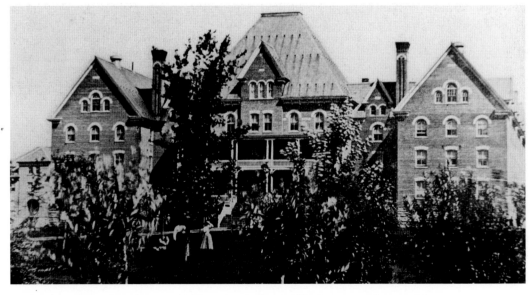

Stroud Hall, affectionately called "Old Main," was built in 1892, the first building erected at the Normal School. Male students were housed in the north wing, and female in the south wing. East Stroudsburg Normal School evolved to a state teacher's college in 1927, a state college in 1960, and achieved university status in 1983. A modern Stroud Hall has long since replaced "Old Main."

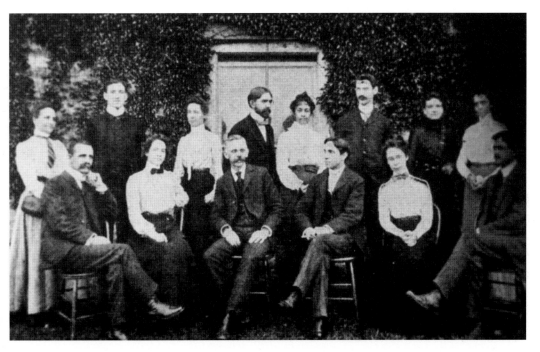

Ivy-covered walls set the background for this scene of the Normal School's faculty and staff in 1902. Among them are: Elwood L. Kemp (third from left), Principal George N. Bible (fourth from left), and on the far right is Homer Higby (mathematics teacher and football coach). (Courtesy of ESU.)

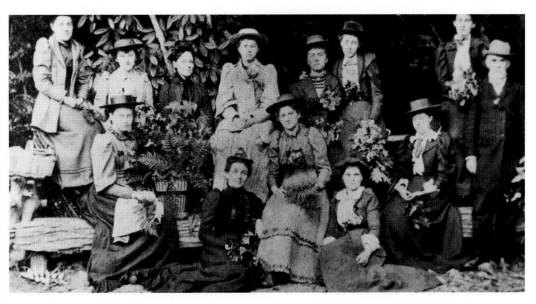

The year was 1894, and members of the first graduating class of the Normal School went on an outing with ESSN's first science teacher, Dr. J.A. Curran and his wife. Mrs. Curran, as chaperone, is pictured in the back row, third from the left. (Courtesy of ESU.)

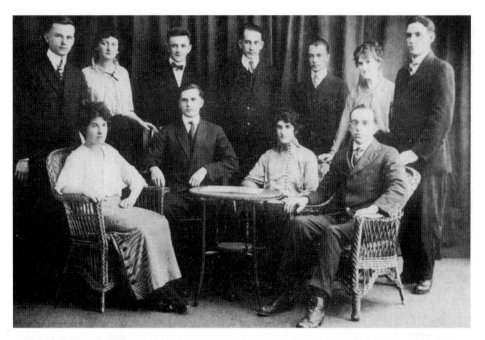

Pictured is the Normal School's Press Club in 1915. Members from left to right are: (seated) Anna Boland, Anthony Ratchford, Ruth Lloyd, and Harry Dew; (standing) Aloysius Kane, Marie Walsh, Fred Wall, A.E. Laufer (faculty advisor), John Coyne, Mary Sullivan, and Ervin LaFrance.

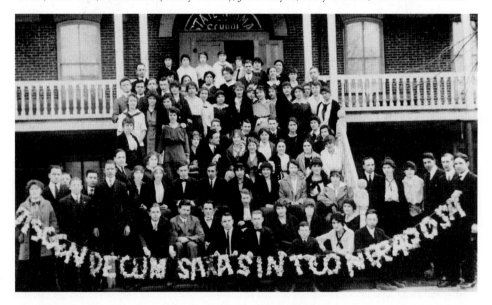

The Minisink Literary Society at the Normal School displayed their motto "Ascendum cum saxa sint confragosa," meaning "Climb, though the rocks are rugged." The year was 1915, and the Normal School required students to take Latin. (Courtesy of ESU Alumni Association.)

Opposite, above: Members of the Normal School's girls' basketball team posed demurely in their sailor blouses for this 1915 photograph. The team was formed in 1902. (Courtesy of ESU Alumni Association.)

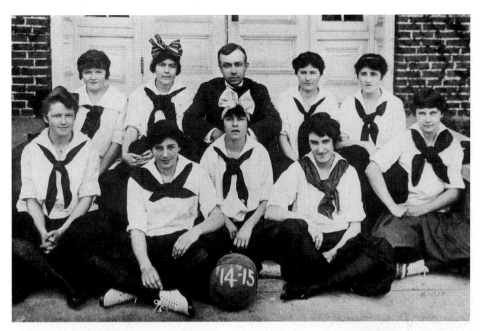

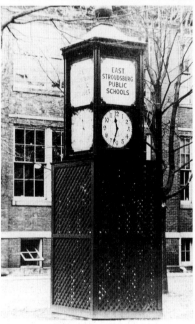

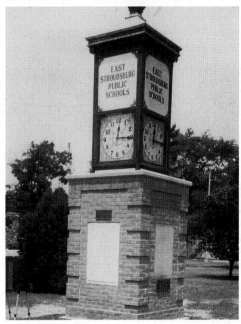

Above, left: Folks around our towns get sentimental about clocks. When East Stroudsburg High School was torn down, the clock was put up for auction and moved. Quite a few sighs of regret were uttered as this treasured timepiece disappeared.

Above, right: "Tempus fugit." Thirty-five years later, citizens spearheaded a fund drive to purchase and restore the clock. Today we gaze proudly upon it as it stands on the grounds of the new high school as a fond symbol of the past and a bright sign of the future.

Acknowledgments

Our heartfelt thanks go to Beulah McConnell, Frank Lanterman, Gertrude Hershey, Charles Garris, the Lees, Bill Quinlan, the Secors, the Florys, East Stroudsburg Area Schools, East Stroudsburg University, Pocono Medical Center, Easton Express-Times, fire companies of both towns, the Salvation Army, historical associations of Monroe and Pike Counties, and too many others to mention in limited space.

If your name is not mentioned, we remember you in our hearts. We dedicate this book to you, the citizens of the Stroudsburgs, for your photographs, your time, your remembrance, and your sharing of memories. People such as you inspire all in our community.